# Clothing on Figures

## HOW TO DRAW FOLDS, FABRICS AND DRAPERY

## Giovanni Civardi

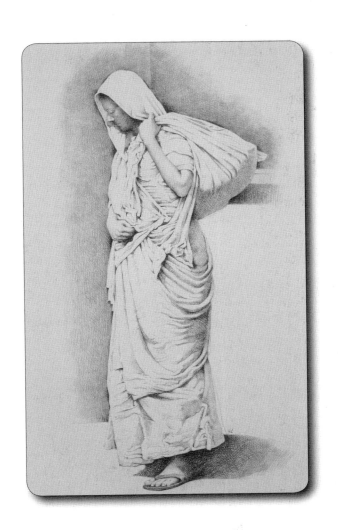

# SEARCH PRESS

Giovanni Guglielmo Civardi was born in Milan in 1947. After working in the fields of illustration, portrait drawing and sculpture, he has specialised in anatomy for artists for many years and teaches human figure drawing courses.

October, 2012

First published in Great Britain in 2015 by
Search Press Limited, Wellwood, North Farm Road,
Tunbridge Wells, Kent TN2 3DR

Originally published in Italy by Il Castello Collane Tecniche, Milano

Copyright © Il Castello S.r.l., via Milano 73/75, 20010 Cornaredo (Milano) Italy, 2014 *Il Panneggio e la Figura Umana*

Translation by Burravoe Translation Services

Typesetting by Greengate Publishing Services, Tonbridge, Kent

ISBN: 978-1-78221-230-0

The figure drawings in this book are of consenting models or informed persons. Any similarity to other persons is purely coincidental.

Printed in Malaysia

# CONTENTS

*Cultivate an ever continuous power of observation.*
John Singer Sargent

*The photograph is an immediate action drawing a meditation.*
Henri Cartier Bresson

*Whenever and as long you think of another, he lives...*
G.C.

*The philosopher condenses thought, the artist dilutes it.*
G.C.

# INTRODUCTION

*The drapes that clothe figures must show that the figures live within.*
Leonardo da Vinci

*Always search for the desire of the line, where it wishes to enter or
where to die away.*

Henri Matisse

Every artist has their own way of depicting folds, fabrics and clothes. This depends upon their own cultural sensitivity as well as the period they live in, conditioned by popular or religious beliefs, philosophical thought and scientific notions. These are all elements that contribute to creating style. In figurative works of art, drapery is the result of arranging (intentionally or by chance) the fabric and folds that make up clothing or cloth that covers a figure, in a close relationship with the position or movement of the body. The terms 'drapery' and 'drapery' apply also to furnishing, nearly always synonymously and interchangeably. The second one however is used more often in reference to soft furnishings (on walls or furniture), which makes use of cloth (either actual fabric, or in the form of a fresco or bas-relief), hung in the form of valances or swags, or allowed to fall as a curtain. The history of costume and clothing is a subdiscipline of history, in the wider sense, in the same way as archaeology or art history, and uses the same research methods. When expounding on the art of different civilisations, the study of drapery is always closely linked to the depiction, including symbolically, of the nude and of historical, religious and mythological personages. Besides its role as a medium for communicating aesthetic values (as an ornamental, scenographic, functional or status-related theme), the way we depict clothing or cloth folds that cover the body also becomes a way of representing status (for example, as a sign of opulence, power, or sensuality). We need only look at the works of various artistic cultures to perceive the large number of ways that drapery, and even more, its different symbolic styles, can be interpreted. We can see, for example, the initial schematism and later naturalness of Greek art, or the compact, abstract, stylised or conventional tendency that is a feature of medieval art and then later seems to decline (especially Romanesque and Gothic art). From the Renaissance onwards, a period when drapery took on a deep symbolism (so much so that aesthetic theories were put forward consistent with theories on the human figure), to the Baroque era (characterised by luministic effects, over-abundance, and technical ability), to Neoclassical sobriety or modern clothing and the academic exercises of the 19th century, there are numerous examples of works where we can recognise both the stylistic influences of the era and the personal preference of the artist.

In contemporary art, the emphasis is generally no longer on realism or mimesis, which have fallen out of favour, except for some individual artists working in the fields of traditional art, figurative art, portraiture or illustration. We may ask ourselves, then, why the study of drapery is useful for the artist's training. The answer may lie in the potential of a method of technical, manual learning, and above all, in honing the skills of observation and summary that derive from this type of study. For example, drawing, painting or shaping a draped fabric on a figure necessarily means carefully observing the naked body (because it is important to identify the anatomical points from which the fabric is suspended on the body) or improving the composition of the work (for example, as an element of a still life or as a free-standing theme, one that can be essential to the point of abstraction).

Indeed, artists (while preserving full liberty to make use of art forms which they believe are best suited to their personality and intentions) should practise looking at all that surrounds them. Draped fabric thus offers an opportunity for improving drawing technique (paying attention to chiaroscuro effects, tonal layers, the texture and surface of the fabric, etc.) and above all, observation (making a judgement about the significant folds and thus the right balance between simplicity and complexity).

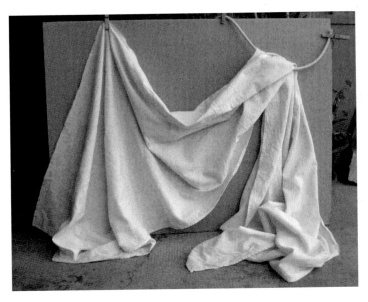

# FOLDS AND FABRICS

Drapery refers to the way fabric falls naturally in relation to the form it covers governed by the force of gravity. It is an important stylistic element in life drawing and is conventionally arranged to look harmonious against the human figure.

In its wider sense, drapery can be understood to refer to clothing. Conventional, artificial drapery can be considered a human invention; however, the natural folds of garments cannot be invented, nor can they be precisely reproduced in real life due to many intricate variables.

The shape, density and direction of the folds can depend on the thickness of the fabric that produces them. The main rule that governs the direction of folds in drapery tells us that, when worn or simply laid on a body, fabric hangs on at least one identifiable point, whence the folds radiate outwards.

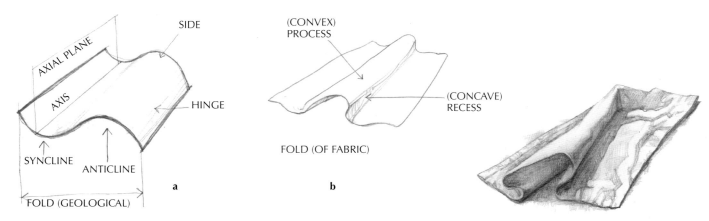

Geological folds (a) and fabric folds (b) have many similarities. Earth sciences study geological folds, which are caused by forces of compression, acting over time on rocky material with plastic characteristics, producing deformations, of varying degrees and dimensions. The sharp fold is formed by the meeting of two inclined planes which join at the line of maximum curvature, the hinge (or top), the development of which defines the axis and the axial plane. The fold that is concave on top is called a syncline and the one that is concave underneath is known as an anticline.

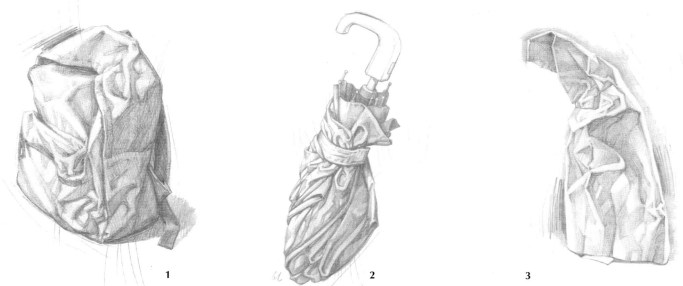

Fabrics of various origins (natural or synthetic) are used not only to make clothes but also many everyday objects, such as a backpack or an umbrella (1, 2). Studying rumpled-up or folded paper (3) of different thicknesses can be an interesting and useful exercise.

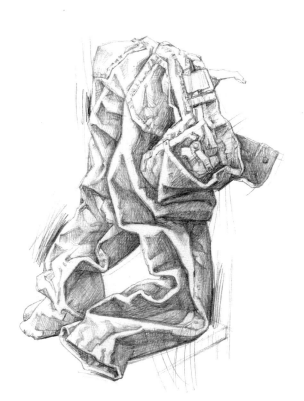

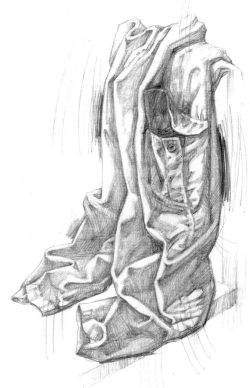

*The fold effect produced by a heavy fabric (denim jeans)*

*The fold effect produced by a lightweight fabric (broadcloth)*

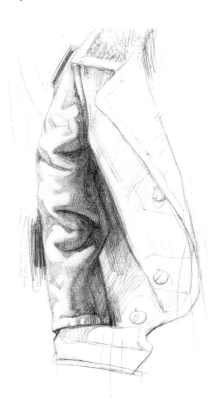

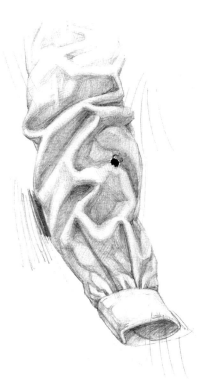

*The fold effect produced by a very heavy fabric (sheepskin)*

*The fold effect produced by a very light fabric (linen broadcloth)*

Heavy fabrics make very few folds, which are wide and deep, while light fabrics produce many folds, which are close together.

# THE ANATOMY OF FOLDS: STRUCTURE, FORM AND TYPE

The thickness of the fabric and the underlying form affect the depth and direction of the folds. However, all folds have a few points in common and artists have identified and named a series of noteworthy points. Throughout the history of art, we can see many ways of depicting clothing on figures, a result of either common ideas of aesthetics, or others that depend on the subjective preferences of individual artists. For example, in Western art, drapery has been influenced by the prestige of images of classical art (especially sculptures). And yet the medieval period shows a departure from the classical tradition. The Romanesque period, for example, shows preference for tapered clothing on figures. In later periods, a large variety of forms developed, inspired by the individual stylistic features of different European countries (more classical and naturalistic in Southern Europe, but more structured, lavish and geometric in the Nordic countries).

There are thus several recognisable types of natural and arranged folds (for example: straight or curved, wide or narrow, thick or thin, deep or shallow, etc.); various ways of distributing the folds (for example: vertical, slanted, diagonal, curvy, spiral, bow shaped, diamond shaped, fan shaped, concentric circles, etc.) and depicted using different styles, belonging to two diametrically opposite groups: one with angular lines, hard, dry, essential and schematic, and the other with soft, blurred lines, fading gradually and blending into the background.

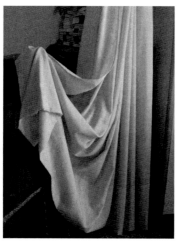

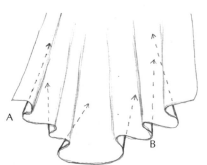

When we draw complex arrangements of clothes or drapery we need to pay attention to the actual direction of the folds, especially the ones that are partially hidden. In the drawing on the left, the arrows on folds A and B are pointing in the right direction. The other arrows are imprecise or incorrect.

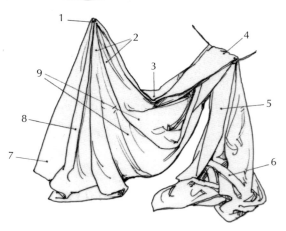

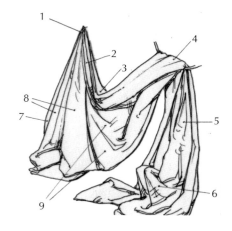

Commonly used artistic terms referring to clothing on figures:

1   Point of support (where the fabric rests or hangs). This is the point or length of fabric that is fixed in place with buckles, ties, pins, etc., or it rests on projecting parts of the body (shoulders chest, knee, etc.).
2   Chord. A very thin, tightly pulled part of the draped fabric.
3   Sag or diaper fold. This is the concave or sharply folded form that is produced where the fold bends, and is also the part that protrudes the most.
4   Suspension area. This is the part of the fabric that is kept raised with respect to the rest of the draped fabric.

5   Drop (or fall). This is the part of the fabric that falls from where it is kept raised (or supported) simply due to gravity.
6   Turn-up (or backfold). This is an extra or upturned part of a piece of cloth, or the end part of a drop, where the fabric is allowed to fall to the ground and fold over itself, giving rise to various forms of folds.
7   Skirt (edge or hem). This is the end or margin of the fabric.
8   Pipe. This is a vertical tubular fold. If instead it is horizontal, it is known as a 'shawl' or 'drainpipe' fold: it is formed when the fabric is attached at two points and falls towards the centre in a few soft waves.
9   Fold. This portion of cloth folds onto itself. It can take different shapes, directions, sizes, etc.

Two types of drawings: tonal (pencil drawing) and schematic, drawn with an ink pen.

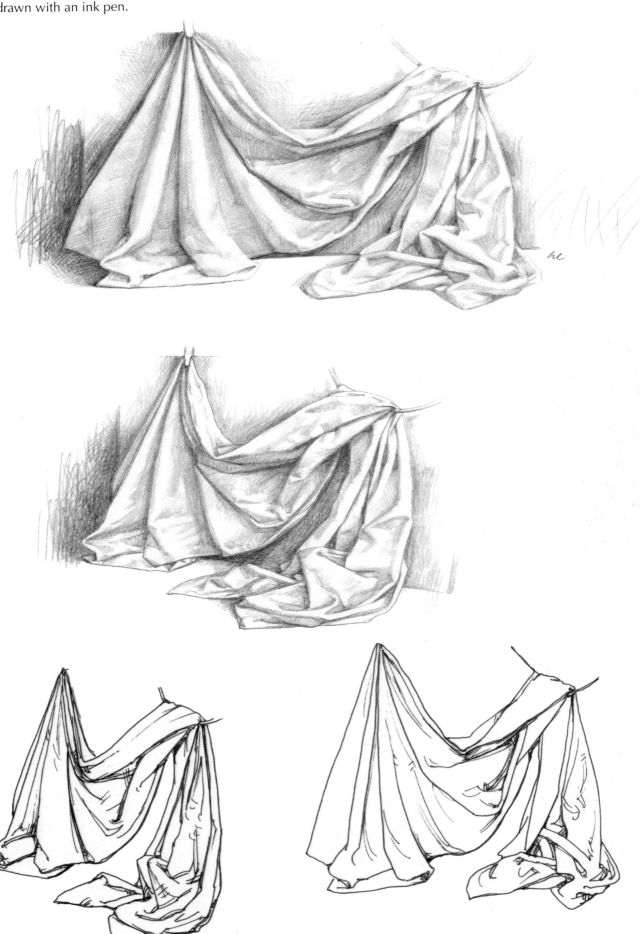

Some generic forms of vertical and curved folds.

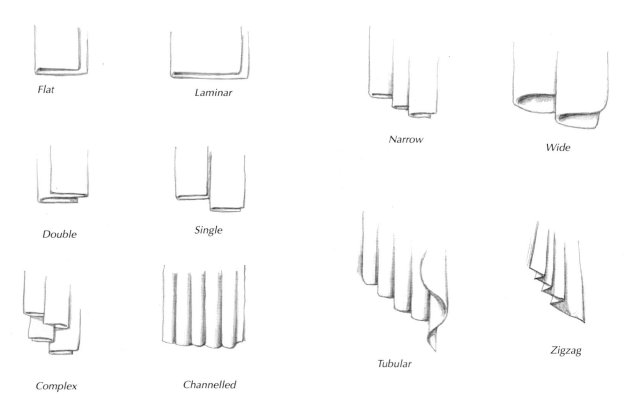

Flat

Laminar

Narrow

Wide

Double

Single

Complex

Channelled

Tubular

Zigzag

Some conventional ways of classifying folds.

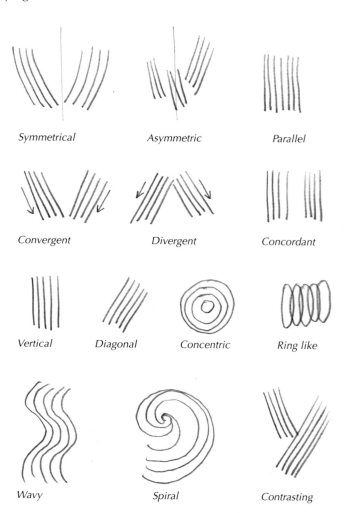

Symmetrical

Asymmetric

Parallel

Convergent

Divergent

Concordant

Vertical

Diagonal

Concentric

Ring like

Wavy

Spiral

Contrasting

Some ways of classifying vertical parallel folds (these have been simulated by folding a sheet of paper).

*1 – single fold*

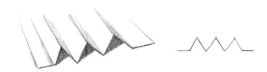

*2 – series of parallel single folds (zigzag)*

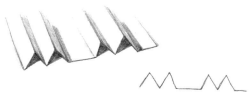

*3 – series of paired single folds*

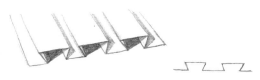

*4 – double parallel flattened folds*

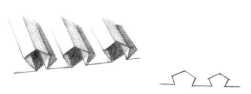

*5 – double parallel triangular folds*

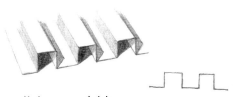

*6 – parallel square folds*

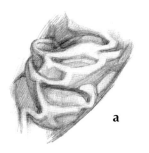

**a**          **b**

*7 – parallel slanted column folds*

*8 – parallel tubular folds*

*9 – parallel flattened column folds*

*10 – asymmetric spiral tubular folds*

*11 – curved drop edge*

*12 – superimposed layers*

*Density of folds in fabric*
*(a) = few folds; in a light fabric*
*(b) = many folds; in a heavy fabric*

# ILLUMINATION: LIGHT AND SHADOW

Light acts on fabric just as it does on any other object. Its direction and intensity determine the quality of the play of shadows which create an overall tonal effect, which is so important in suggesting a sense of volume and depth in a drawing. A drawing made for the specific purpose of studying drapery in depth requires a fairly long time to execute and it is usually done in a closed room. This is why it is a good idea to use a stable source of light. This could, for example, be daylight coming from the North (which remains practically unchanged for most of the day) or artificial light, diffused and oriented in an oblique direction, so that the resulting shadows correctly highlight the points of support and folds, without creating a flattened image or excessively strong contrasts. In cases when the light source is too intense or concentrated, resulting in deep, sharp shadows, it might be a good idea to use a reflecting shield (something as simple as light coloured cardboard, for example) that captures a part of the light and reflects it back on to the draped fabric, attenuating the tonal contrast. This is a trick that photographers also use.

Chiaroscuro terminology can be used for any illuminated object, whether it is a complex draped fabric or a simple geometric solid:

1 – Illuminated area/side
2 – Reflected light
3 – Core/form shadow
4 – Cast shadow
5 – Shadow accent
6 – Shadow line ('hump')
7 – Half tone
8 – Penumbra (outer shadow)

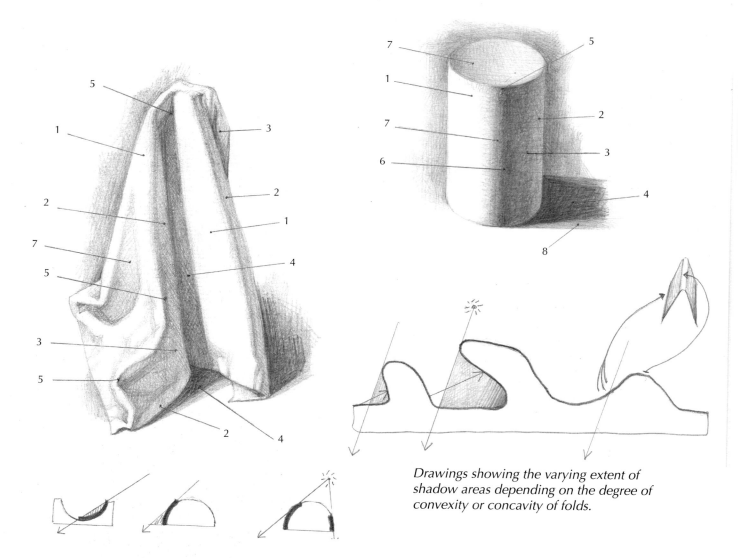

*Drawings showing the varying extent of shadow areas depending on the degree of convexity or concavity of folds.*

1 For more information on this topic, see my book *Drawing Light & Shade: Understanding Chiaroscuro* (2006), also in this series.

a

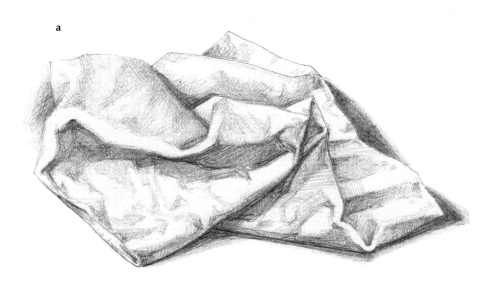

*The effect of two different types of lighting on the same draped fabric: (a) diffused natural light; (b) diffused artificial light.*

b

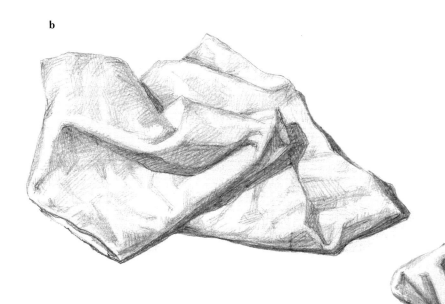

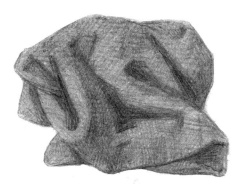

The chiaroscuro or tonal contrast effect on the inner side of folds varies according to whether the fabric is white or coloured and whether the colour is light or dark. The mixture seems even more complicated if there are printed designs on the cloth. Only careful observation allows us to simplify and effectively resolve these features of drapery.

# SOME PRACTICAL CONSIDERATIONS

Here is a brief series of notes listed in no particular order, which I used to give to the participants of my figure drawing classes, as notes to help them remember the lessons.

- In the first drapery exercises, observe and draw fabrics of any type and thickness, positioned (casually or according to an aesthetic criterion to make a composition) on fixed supports such as a chair, a table, a box, etc. This way you can take your time and examine the fabric accurately and avoid the problems of movement and rest breaks that you would have with a living draped model.

- To start with, it would be a good idea to choose a pale coloured fabric (white, grey, etc.) with a uniform texture. This allows us to better perceive the structural and chiaroscuro characteristics of the folds than would be possible with a dark or intense colour.

- Not only fabrics, but all soft materials (paper, plastic sheeting, tanned leather, etc) can produce folds. It is important to reproduce the organoleptic surface features (shiny or opaque, smooth or rough, etc.) but not as important as it is to draw the folds in an effective and convincing manner. Drawing draped fabrics means drawing the folds at the same time as the texture and surface characteristics of the fabric.

- Arrange the fabric on the support (a chair, for example) or hang it on the wall, so as to create some movement between the parts of the draped fabric: one portion can descend flowingly, with nearly parallel folds, while the rest falls freely and gathers on the ground, resulting in folds of different sizes and directions.

- Folds are a collection of straight and curved lines alternating with sharp changes in direction. Therefore it is important to identify the places where folds are curved (concave or convex) and wide and the points where they form an angle.

- A few basic principles regarding drapery and clothing on figures: 1 – No fold should have a direction that contradicts the overall flow of the figure. Every fold should contribute to reinforcing the figure of the nude underneath, revealing it explicitly by its movement, direction and form. 2 – The drapery should suggest an overall trend, a prevailing direction, in harmony with the inclination of the body. 3 – Symmetrical repetitions of groups of folds should be avoided. Instead, allow the body underneath to be seen at crucial points, because the variety of volumes creates an effective play of light and dark (chiaroscuro) and gives a rhythm to the arrangement of the folds. 4 – All the major lines produced by the folds spread out at the points of support on the nude body, each of which then becomes a central point from which the folds radiate out.

- It's important to remember that the inner side of clothing folds can never go deeper than the body surface that the folds are covering.

- When drawing clothing, it's important to look at the overall form. We don't need to draw all the folds that we see in real life. At times, when drawing a figure from memory or imagination, the artist tends to over-define shapes and tones, producing a confused effect and resulting in something that does not resemble the original.

- To really understand the effect of movement on clothing, besides the thickness of the fabric, we need to consider other factors such as tailoring details, for example the 'cut' and the seams, and the presence of belts and buttons, etc. All these are constraints that prevent or limit some movements and which determine the typical radiating folds of some parts of clothing (sleeves, trousers, etc.).

- To start with, it is a good idea to study only some isolated parts of a clothed figure, but after that it is worth extending the observation to various types of clothing: ancient clothing, modern clothing, military or professional uniforms, sports clothing, workmen's clothing, etc.

- Line drawings (ink or pen) compel us to make an intelligent précis of the folds and their chiaroscuro effects. We can use different line thicknesses and combine them, either side by side or by crosshatching.

- On a clothed figure, the drapery effect changes with every movement. It is impossible to exactly reproduce the same conditions later on. It is possible to use photographs, but expert artists know how different it is to take their inspiration from a real live model and to draw (both forms and colours) using photographic images. In the past, painters used life-sized or smaller 'mannequins', on which they arranged the fabric or clothing they wanted to draw, which gave them the time and certainty that they could draw without worrying about a live model's pose.

- The colour of the fabric influences the model's skin tone. This is very important when drawing or painting a portrait.

## Some styles of depicting clothing on figures in art

We have already mentioned the large variety of aesthetic styles, of symbolic conventions and technical expedients made use of by artists of different cultures over the centuries (see page 6). It may be a useful exercise to trace (for example, using tracing paper) simplified draped structures from photographs of works of art (paintings and drawings as well as sculptures), trying to identify and compare criteria that guided artists to imitate reality more or less closely, rather than merely copying real life.

*French art, 12th century*

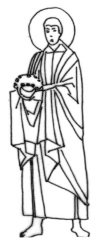

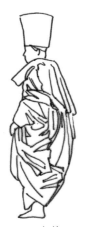

*Ravenna, 6th century*

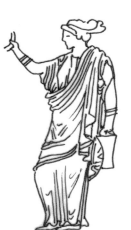

*Piero della Francesca, approx. 1460*

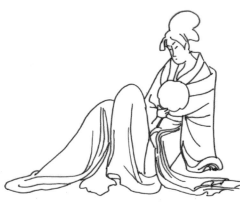

*Classical Greece, 4th century B.C.*

*Japan 17th century*

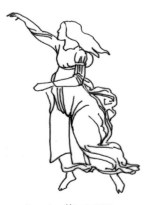

*Botticelli, 1485*

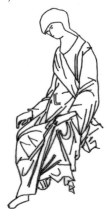

*Rublev, 1411*

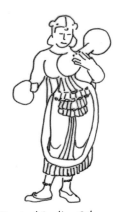

*Central India, 8th century*

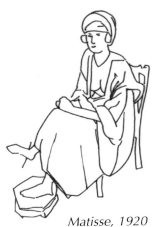

*Matisse, 1920*

## Drawing methods

With practice, each artist finds their own style of drawing, which is a product of their own personality, abilities, technical skills, and aesthetic purpose. When starting to study it is a good idea (and one that comes naturally) to limit yourself to trying to draw a model realistically (see page 16), but you can soon move away from this to try new experiments and find ways of drawing that are more concise, vibrant and meaningful. The two drawings below suggest two different ways of drawing from real life from among the many possibilities.

*Tonal and realistic/ analytical drawing*

*Linear and schematic/ concise drawing*

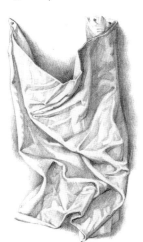

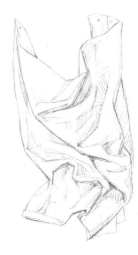

# SOME DRAWING TECHNIQUES

Many materials are suitable to draw with. Graphite pencils, charcoal or pen and ink are examples of the most well known and frequently used ones. All of these produce a single coloured line, going from white to black, passing through a series of intermediate shades of grey. They are therefore ideal for a quick, concise sketch, as well as an accurate and in-depth study of drapery on figures. We can also easily use other materials, coloured ones (inks, coloured pencils, pastels and chalks, felt-tip markers etc.) that efficiently integrate colour and tone characteristics. The choice of material (and the application or mixing techniques for each one) is at the artist's discretion and is suggested by the organoleptic qualities of the fabric that is to be drawn. For example, the graphite pencil allows for a very accurate tonal analysis and is suitable to draw the surface of fine and light fabrics; charcoal allows for larger sized studies and can be carried out on thicker and rougher fabrics; pen and ink help to define smaller details, typical of embroidered or decorated fabrics, etc.

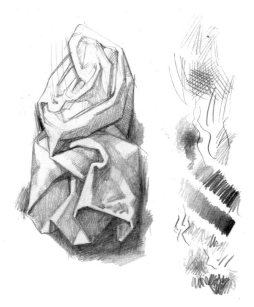

*HB graphite lead – The drawing in this example has been done using a medium hard (HB) microlead graphite pencil. The varying intensity of the grey lines has been obtained by changing the pressure of the lead on the paper or by varying their darkness or proximity to each other and making crosshatched lines in different directions.*

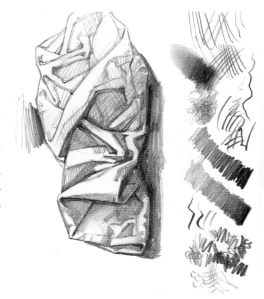

*8B graphite – For this drawing, much softer graphite (8B) in bar form was used instead. The blacks and greys are more intense and compact. A more delicate shading can be obtained by lightly smudging the darker graphite lines with a finger.*

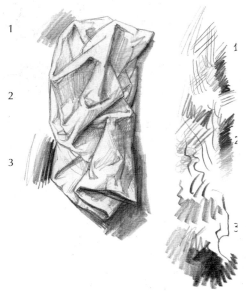

*Various graphite leads HB, 2B, 4B – You can use several graphite leads of different hardness in the same drawing. In this example, the upper part (1) has been drawn with HB; the middle one (2) with 2B; and the lower one (3) with 4B. However, mixing several types of graphite in the same drawing can cause disunity in the style and lead to an affected rendering, lacking coherence in the tonal planes.*

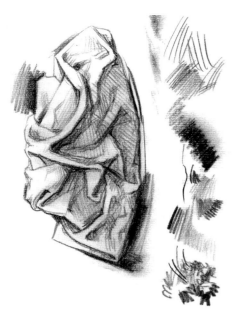

*Charcoal* – Compressed charcoal was used for this drawing, as it offers the possibility of more intense blacks, adhering better than vine charcoal. The main characteristic of charcoal is that it allows us to delicately shade tones by simply rubbing the lines we have drawn with the fingers or a cloth or a blending stump. You can lighten tones and erase lines by using an eraser (a kneaded eraser or putty rubber) which is much softer than the type used to erase pencil marks.

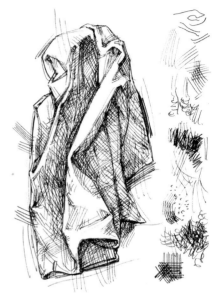

*Pen and ink* – Ink may be applied to paper using a variety of tools: a fountain pen, a ball-point pen, a bird feather (plume), a bamboo reed or a metal nib. In this example, the intensity of the ink lines and the ink itself remain unchanged and the different tones are produced and graduated using a more or less intense and regular amount of crosshatching or by using closely packed dots and short, irregular lines (stippling).

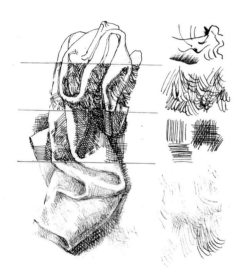

*Pen and ink of various dilutions* – In the lower part of this example, the ink has been diluted with varying amounts of water, so as to obtain tones of at least three or four degrees of intensity. Three different methods have been used in the rest of the drawing: simple lines (smudged in a few places using a finger on the wet ink); with free-hand casual contour; with parts filled in with right-angle crosshatching (typical of intaglio etching).

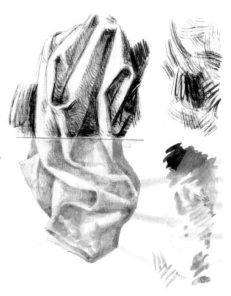

*Dry brush and wash painting* – Ink can also be applied using a small, soft brush. The upper half of this illustration shows the application of the so-called dry brush technique (the brush is squeezed dry by removing the excess ink with a cloth). The single brush stroke shows the granular texture of the paper and is made up of fine parallel lines. Wash painting has been used to create the lower half of this figure. The ink tones have been suitably graded by diluting them with water following standard watercolour techniques.

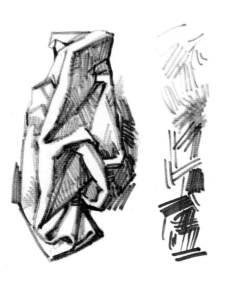

*Felt-tip pen* – The commonly used and well known felt-tip pen is a very effective and practical substitute for the pen. Besides taking advantage of the size and shape of the tip (narrow, thick, chisel shaped, etc.), the colour of the ink and combining it with other instruments, it can also be interesting to make use of different degrees of wear and different ink densities or flows: nearly all dry felt-tip pens leave faint and uneven marks, ideal for drawing intermediate tones.

# ONE WAY TO DRAW

It is possible to draw in different ways, and with different aims (see page 13). Thus, you can make a purely linear sketch (b), where you are looking only at the outlines; a purely tonal sketch (a), where the shape and volume are highlighted, using only shading of light and dark areas; or you can combine lines and tones, in different proportions, in your drawing. The subject of drapery is, above all, a chance to study forms and tonal effects with the aim of applying them, when you have more experience, to more complex work, for example, portraits or landscapes. But it

can also be an independent subject in its own right, where the artist reveals his/her freer and more personal style. Folds can be drawn, for instance, in a 'flowing' way (with curved and wavy lines) or in a 'sharp' way with the aesthetic attention concentrated on structure and volume. In addition to practising with the pencil and charcoal, it would also be advisable to try with pen and ink (c), because this leads to a synthesis of form and simplification of the lines in the fold.

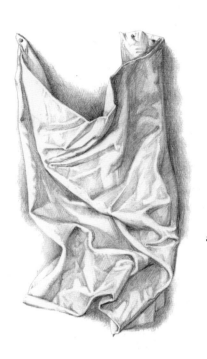

a

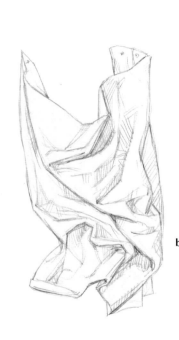

b

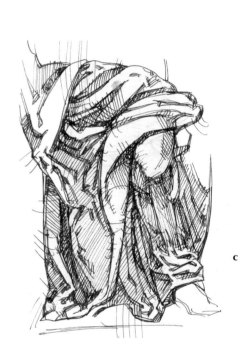

c

One way of drawing naturally is the sight-size method: draw the subject, from real life, with the size and tones exactly as they appear. The sketch shows the procedure, which is somewhat intuitive: when seen from the set view point, the subject and the drawing surface should be the same size. The subject can be propped with a support. Depending on whether its position is closer or further away, the drawing will be either larger or smaller.

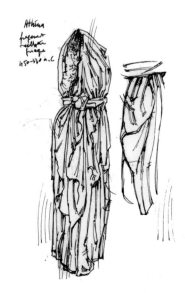

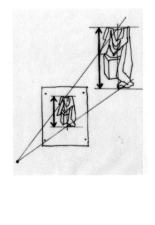

A basic, 'academic' exercise which you can follow for your first drapery studies.

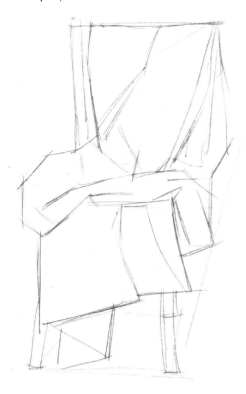

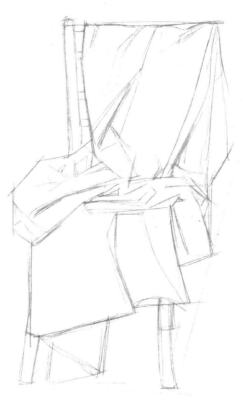

*Phase 1 – Schematic outline of the whole, with lightly drawn structural lines.*

*Phase 2 – Marking the points of tension and the principal lines that radiate out from them.*

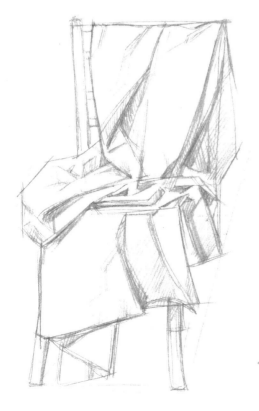

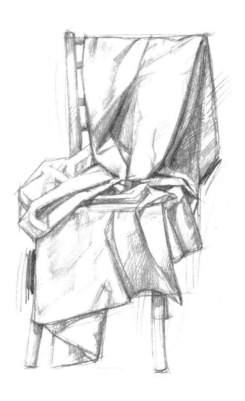

*Phase 3 – Marking the principal chiaroscuro effects, that is, the foreground tone of the fabric and the deepest and most significant shadows.*

*Phase 4 – More precise shaping (though still selective and concise) of the shape of the folds, the light and dark planes, and tonal accents.*

# PERSPECTIVE AND FORESHORTENING

The visible effects of perspective apply to clothing on figures in the same way as they apply to any real object.

This is a conventionally accepted graphic method of representing depth on a flat surface. It follows a few simple rules, which are summarised in the sketch below. The perspective view is useful especially when drawing clothing that covers the human body.

The angular (or oblique) linear perspective takes two vanishing points (VP1 and VP2) located at the two ends of the horizon (H), which we assume is at the observer's eye level. Objects are seen from their corners and their sides seem to become smaller as they converge towards the vanishing points.
The effects produced by perspective on views of clothing or draped fabric (for instance, a tablecloth on a table or a shirt sleeve) can be visualised more clearly by likening them to common solid geometric forms (a sphere, a cuboid, a cylinder, etc.).

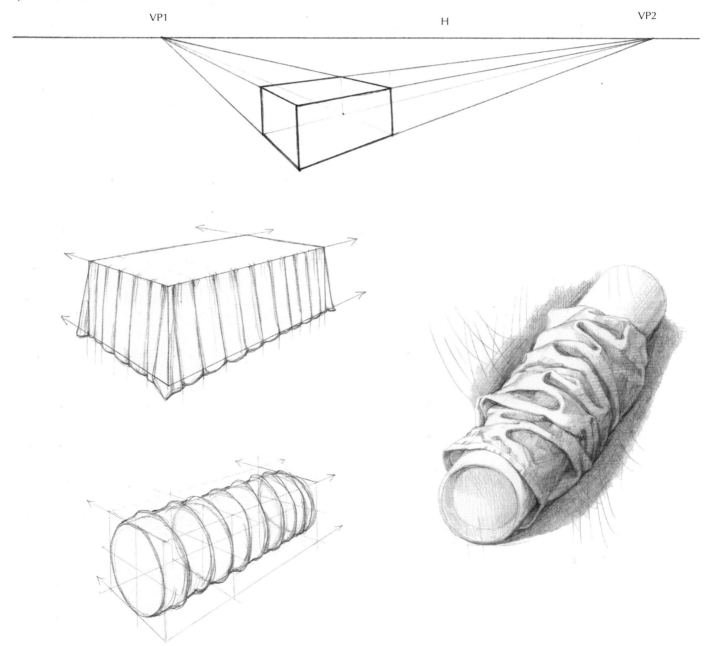

Before studying clothing and cloth draped directly
on the human figure and in real life, it would be
useful to do a few exercises using everyday objects
with a simple geometric shape (for example, a ball,
a cube-shaped box, a small bottle, etc.), with a pale,
solid-coloured lightweight fabric draped over it.
In this way, the points of support and the outward
movement of the principal folds immediately
become clear and easy to draw.

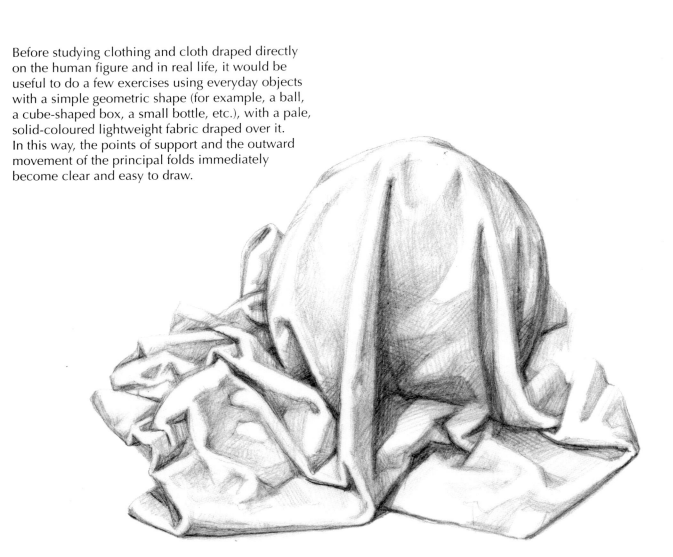

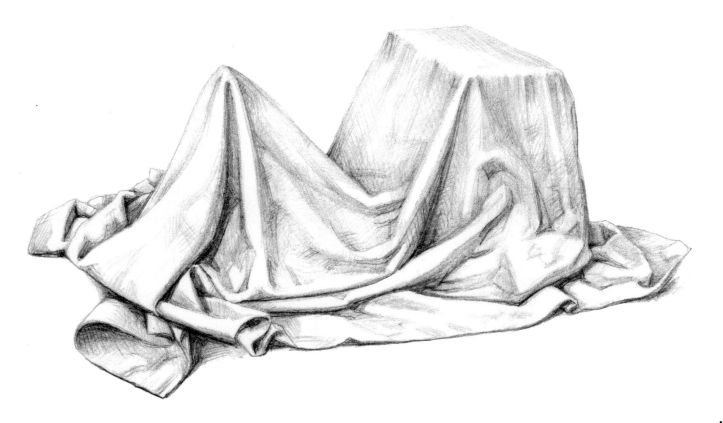

# THE BASIC SHAPES OF FOLDS

Folds do not follow strict rules of arrangement. At times, the results are totally unpredictable and depend largely on the thickness of the fabric, gravity, the solid form on which the fabric rests or the way the wind is blowing. In any case, careful observation of real life can help us to discover typical fold 'trends' and how often they occur themselves under similar conditions. Some typical situations are illustrated in the drawings below. They are worth considering because they simplify the complexity of a draped fabric in an efficient manner.

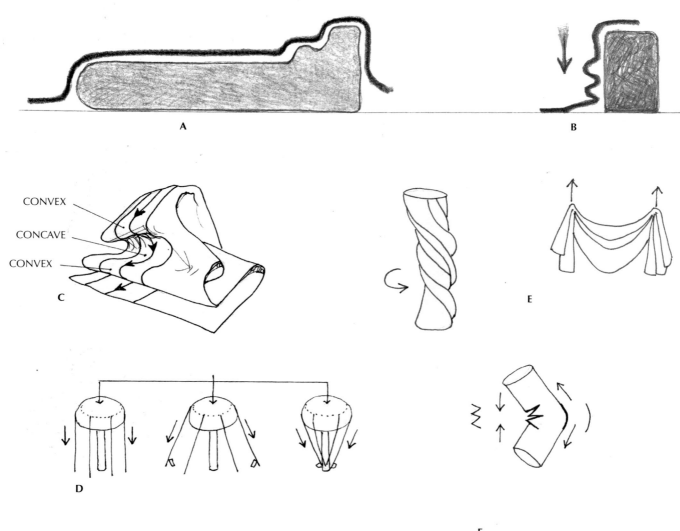

A – A fabric is laid on a solid form (support) and follows its surface (without it ever penetrating the surface).
B – Gravity is a force that always acts and produces effects that depend on the thickness of the cloth.
C – It makes it easier to see the shape of the folds and their convex and concave areas if we use a fabric with printed parallel stripes.
D – Fabric laid on an area of suspension can produce vertical fall folds (parallel), folds that radiate outwards in different directions (if the corners/ends are anchored to distant and fixed points) or folds that converge towards a point of restriction (due to the action of a belt, a buckle, etc.)
E – Effects on the fabric. Bending: compression and a large number of folds on one side, and pulling on the opposite side. Gravity: increased fold density and sagging. Twisting. Suspension and lifting.
F – When lightweight cloth is bent, it produces many small, fine folds. Heavy cloth produces a few wide folds.

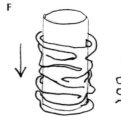

Sketches showing the formation and direction of the
principal folds when a fabric is laid on simple geometric
solids. The dotted lines show the flat or curved supporting
or suspension surfaces.

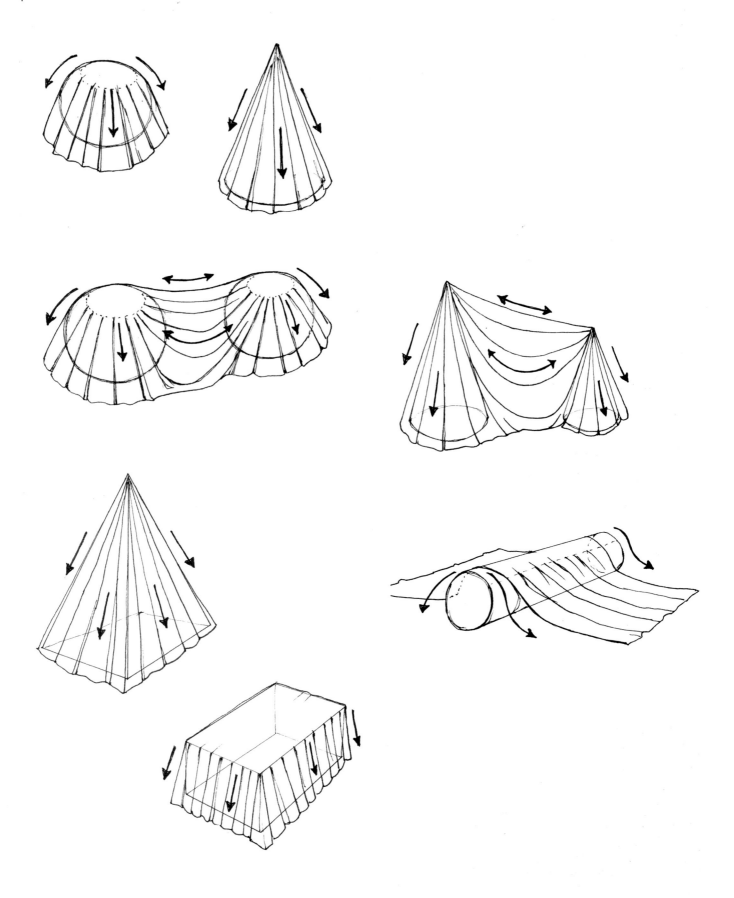

Fold formation in a piece of cloth hung from a single point
(or along one edge).

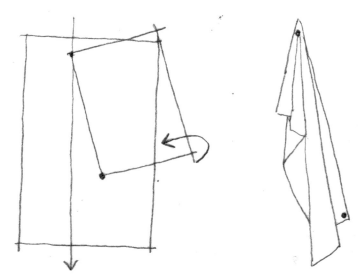

A simple way to make interesting folds. Fix two adjacent
corners of a piece of cloth on a rigid, vertical board, in a
slightly slanted position.

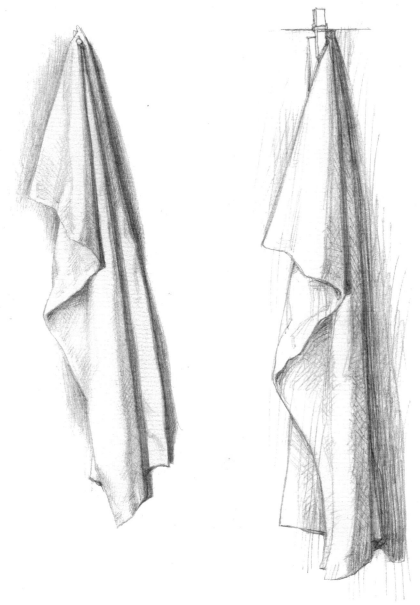

Fold formation in a piece of cloth suspended from two or more points.
   The folds fall in swags, giving shape to deeply concave areas, almost symmetrical and radiating out from each point of attachment. It is easy to recognise this type of drape in clothes from the distant past and ancient times (for example, in cloaks, large shirts, cowls, etc.).

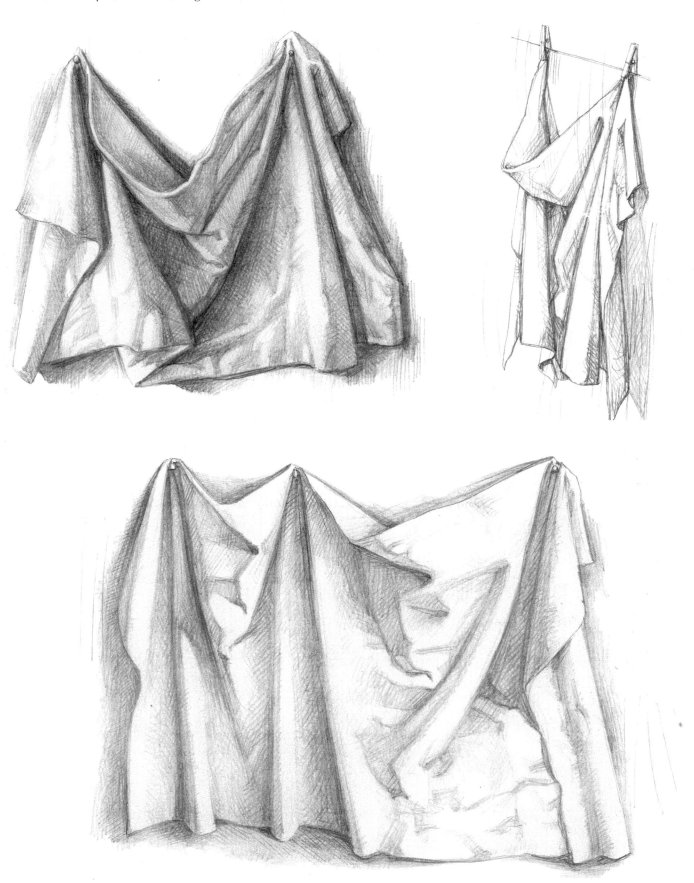

If the two points of suspension of a fabric are at different heights, one higher than the other, the folds take on a diagonal orientation. With clothing, this series of folds is seen, for example, when a figure is static and in counterpose, that is, when the weight of the body is supported by only one leg (while the other is bent), with the resulting sideways turn of the hip.

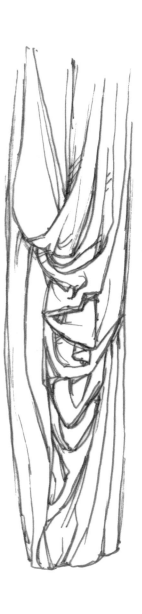

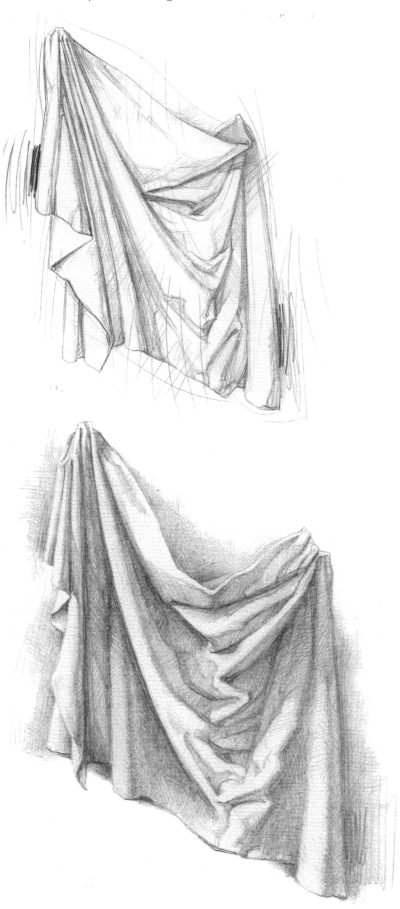

Fold formation in a fabric that is raised and suspended.
   The structure and arrangement of the folds are a combination of the characteristics that we have just mentioned regarding fabric attached to one, two or more points.

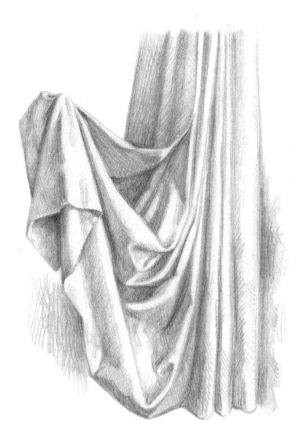

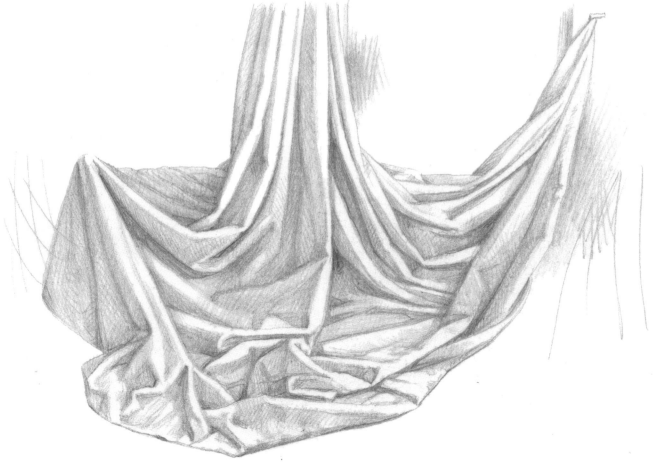

Fold formation in an inert fabric, laid on a surface.
   The folds are formed, bunched and gathered together
solely as a result of gravity and depending upon the
thickness and texture of the cloth. The folds are usually
short, deep and casually oriented in a variety of directions.

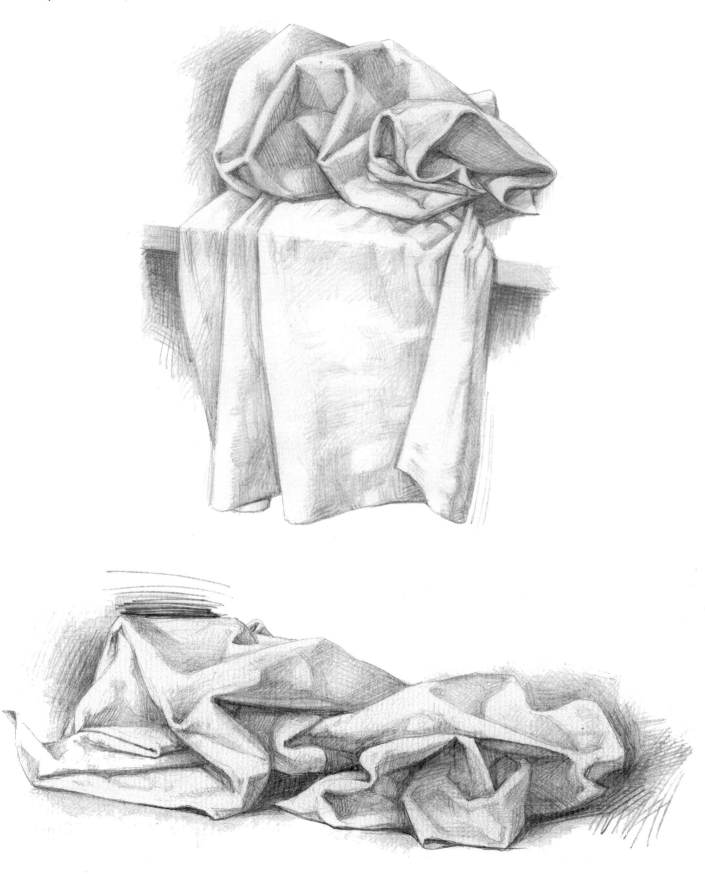

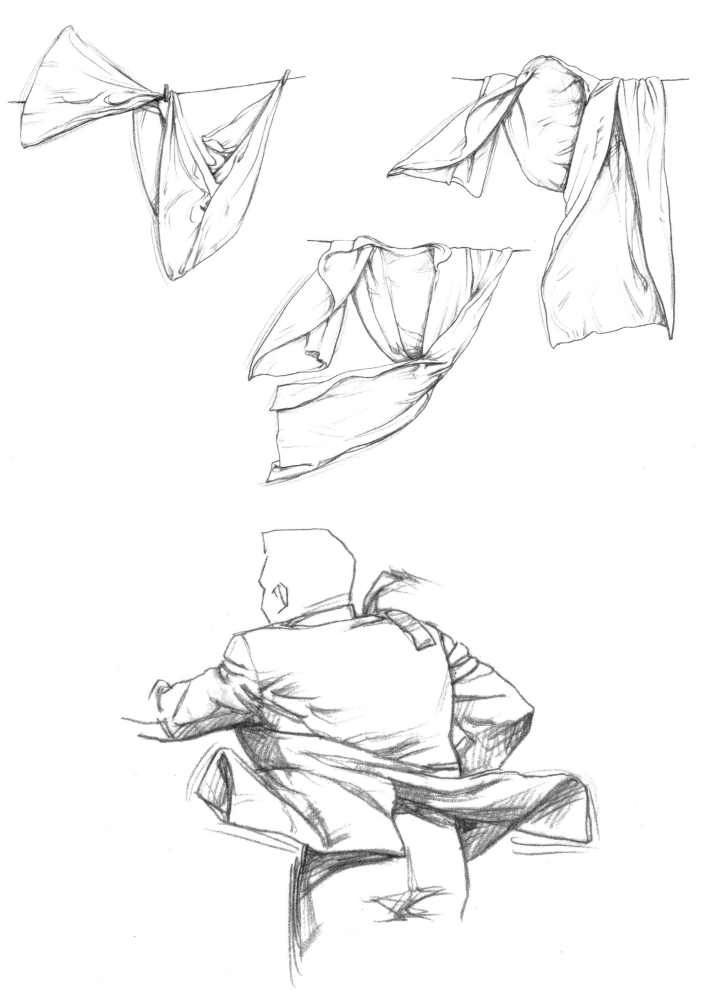

# CLOTHES, DRAPERY AND THE HUMAN FORM

Draped fabrics and clothing highlight the relationship between the body and the cloth that covers it. Clothing and fabrics accentuate human body shapes and make it easier to perceive movements and positions, as they change the drapery, folds and the way the cloth bunches up. Most of the time, the human figure is seen clothed and the artist is frequently called upon to draw clothed persons, for example, in illustrations or portraits. We have already noted that the seemingly casual and irregular arrangement of folds is governed by 'rules', but except for a few general principles, the artist needs to examine them on a case by case basis, depending on the specific circumstances, in the context of his own personal search for expression. And the final purpose for studying drapery is that of giving a graphic rendering, with a few essential and significant lines, to the relationship between the clothing and the body, between the fabric, movement and form. The sketches on this page and the following pages suggest some topics worthy of consideration when observing and drawing clothed figures.

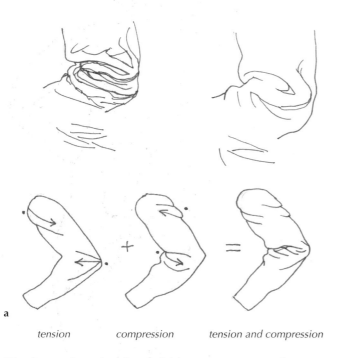

*The texture of the fabric determines the number and width of the folds.*

tension          compression          tension and compression

*The forces that give rise to folds: a – movement; b – gravity. In both cases the result is the sum of the effects of tension (pulling) and compression.*

a

b

c

*Opposing groups of folds. Usually, they: do not meet (a); do not overlap (b); do not intersect (c).*

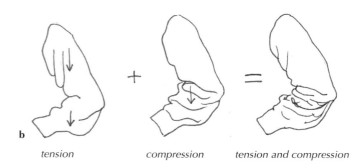

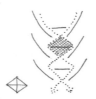

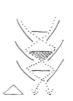

So, in order to correctly capture the folds in a tubular structure (for instance, shirt sleeves, trouser legs, etc.) we need to remember that these folds flow regularly into each other.

Frequently, the shape and length of a fold are influenced by the way it slots into another fold, group or groups of folds. The line of maximum light intensity is at the summit (top) of the folds. These lines come together to delineate small triangular or diamond-shaped shadow areas.

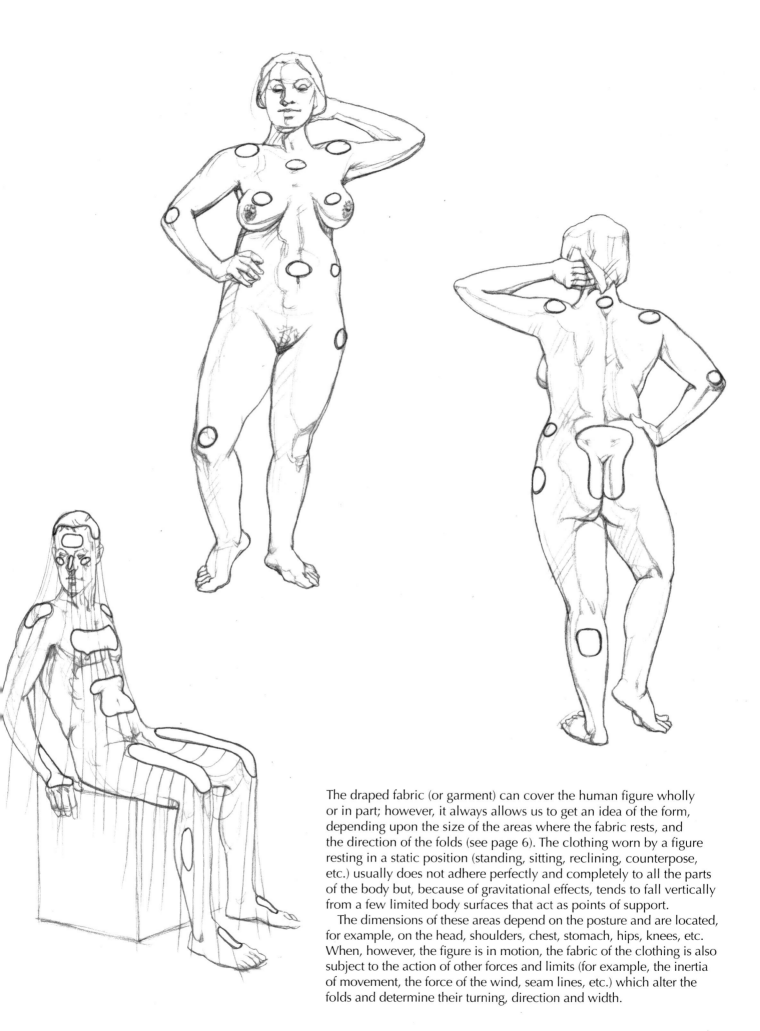

The draped fabric (or garment) can cover the human figure wholly or in part; however, it always allows us to get an idea of the form, depending upon the size of the areas where the fabric rests, and the direction of the folds (see page 6). The clothing worn by a figure resting in a static position (standing, sitting, reclining, counterpose, etc.) usually does not adhere perfectly and completely to all the parts of the body but, because of gravitational effects, tends to fall vertically from a few limited body surfaces that act as points of support.

The dimensions of these areas depend on the posture and are located, for example, on the head, shoulders, chest, stomach, hips, knees, etc. When, however, the figure is in motion, the fabric of the clothing is also subject to the action of other forces and limits (for example, the inertia of movement, the force of the wind, seam lines, etc.) which alter the folds and determine their turning, direction and width.

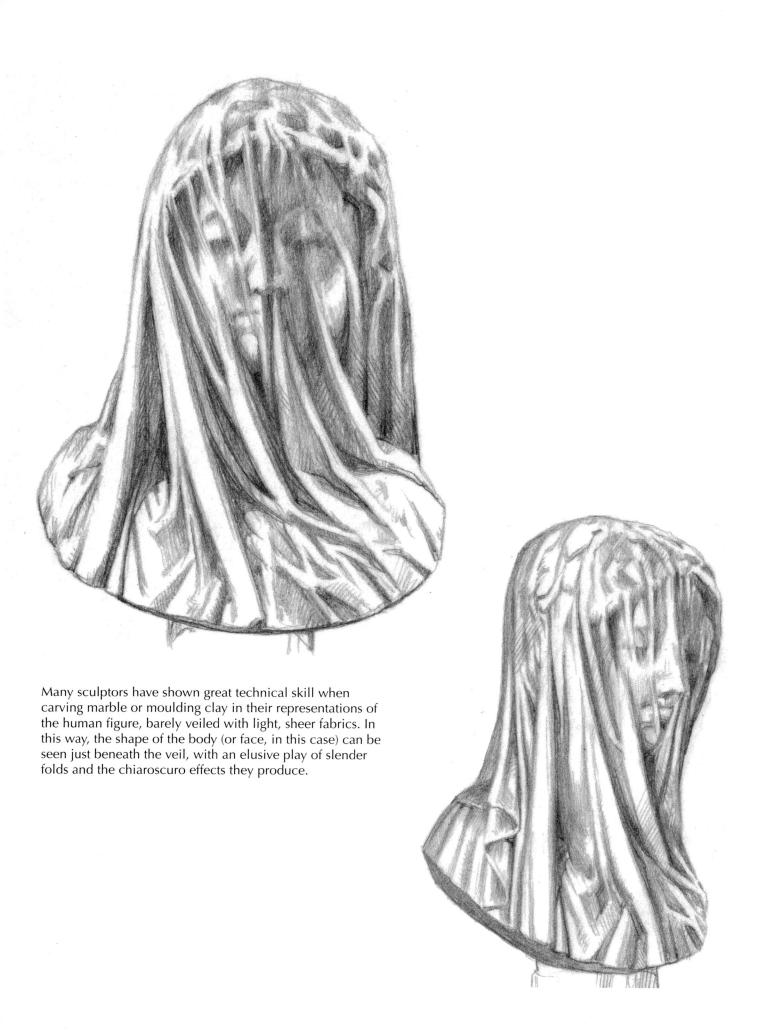

Many sculptors have shown great technical skill when carving marble or moulding clay in their representations of the human figure, barely veiled with light, sheer fabrics. In this way, the shape of the body (or face, in this case) can be seen just beneath the veil, with an elusive play of slender folds and the chiaroscuro effects they produce.

Effects of movement and action on modern clothing are shown on pages 35–36. These simple line drawings are well suited as drawing exercises; simplifying the folds to obtain an effective and expressive result. It is important to pay attention to the points and methods by which the fabric's movement is limited (belts, buttons, seams, etc.) or the protruding parts of the body (shoulders, breasts, knees, etc.) and how the folds start at these points. In illustrations or cartoons it may at times be necessary to draw 'flying' or falling figures, and therefore it is a good idea to consider the direction of the folds and fabric under these conditions. The study of photographs or movie stills can thus be very useful. However, free, selective artistic impressions remain essential in order to reduce the unappealing effect of immobility that is typical of a mechanical image, which 'freezes' movement by making use of extremely fast frames.

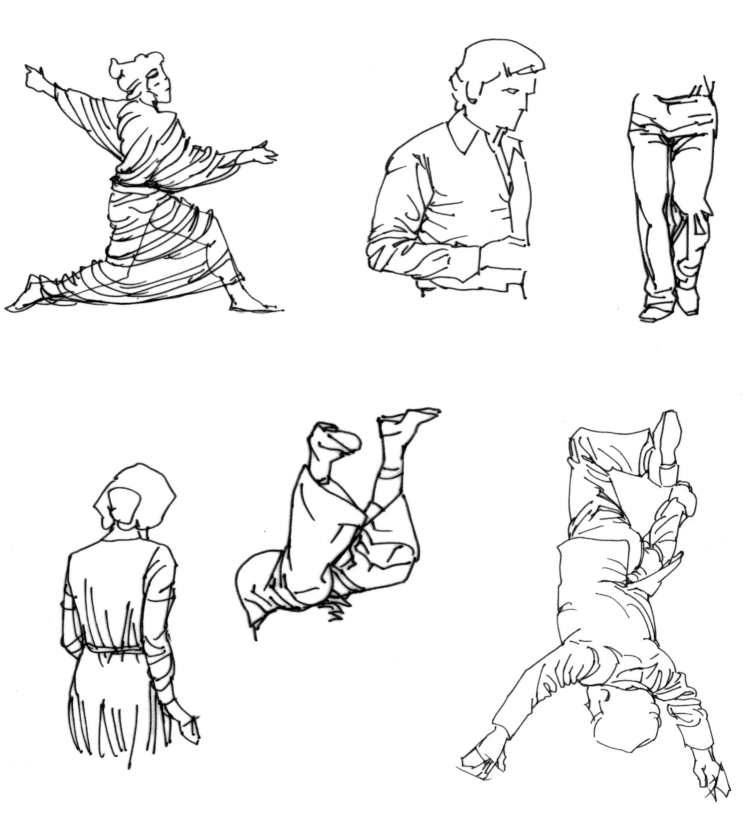

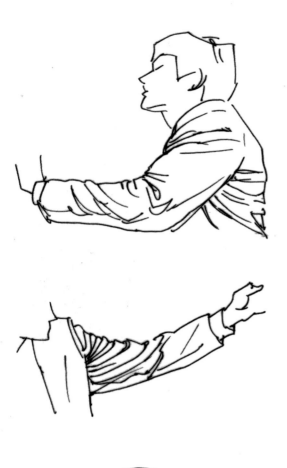

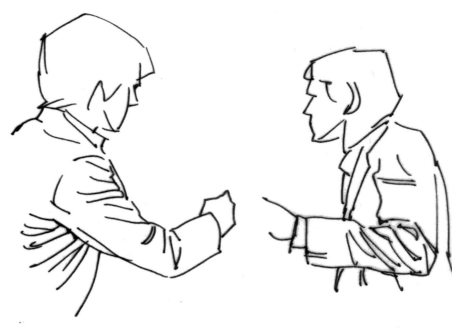

'Fluttering' fabric, lifted by the wind or stirred up by fast body movements, appears to have its edges and the body focussed differently. In a sketch we can obtain this effect by drawing the parts that are in movement (usually, the ends and the free edges) with a softer, fuzzier line and the more stable parts with a more precise, sharp line. The optical effects that we get in this way reproduce those sometimes produced by photography, effectively giving the impression of cloth fluttering in the wind and the direction of movement.

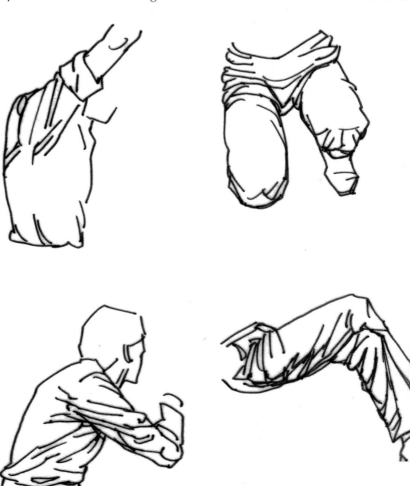

The perspective view (see page 18) produces the visual effect of gathering folds close together. This graphic device for good drawing has been known to painters since ancient times and was put in a very matter-of-fact way by Leonardo, in his *Trattato della pittura (Treatise on Painting)*: '*Where you have a perspective view, show more folds than where you don't.*'

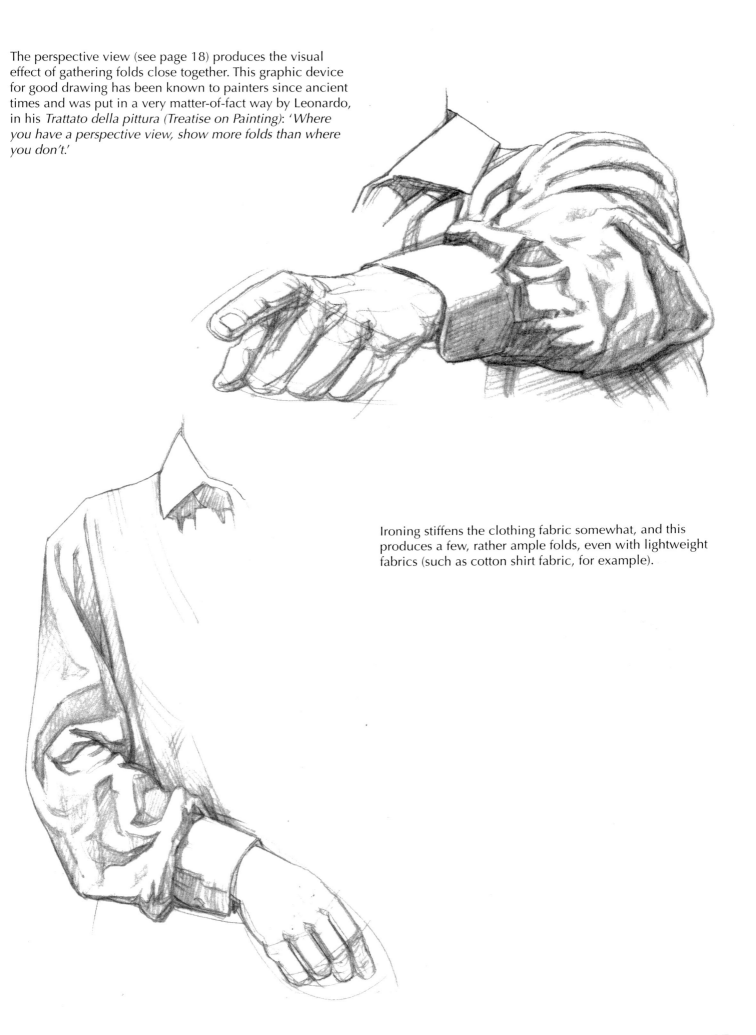

Ironing stiffens the clothing fabric somewhat, and this produces a few, rather ample folds, even with lightweight fabrics (such as cotton shirt fabric, for example).

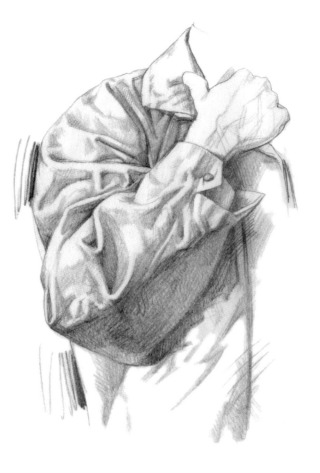

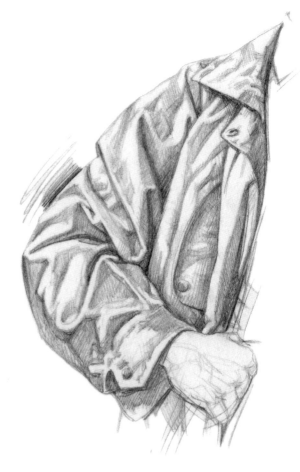

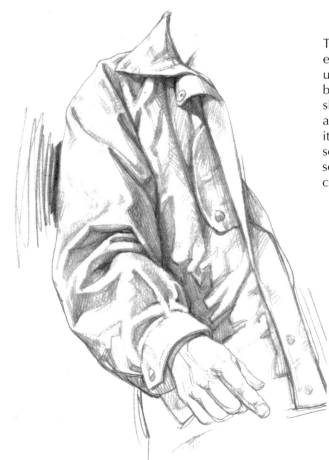

Tonal variation is essential to fully convey a volumetric effect, allowing us to get an idea of the body form underneath, and to get started on paintings. But it should not be too elaborate or detailed, in order to maintain the general shape and 'character' which makes the distribution of light and dark seem credible. When painting clothing on figures, it is not, in fact, necessary to reproduce all the folds that we see in real life: just make a choice, ignoring the small and secondary ones and draw only those that make a significant contribution to the aesthetic effect you are aiming for.

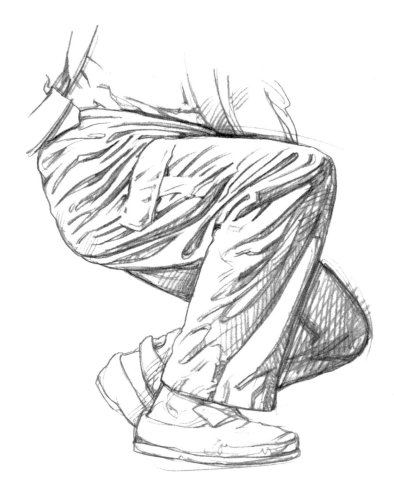

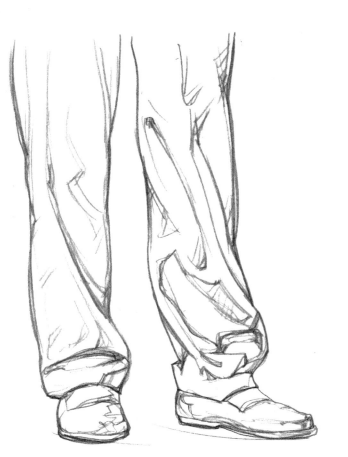

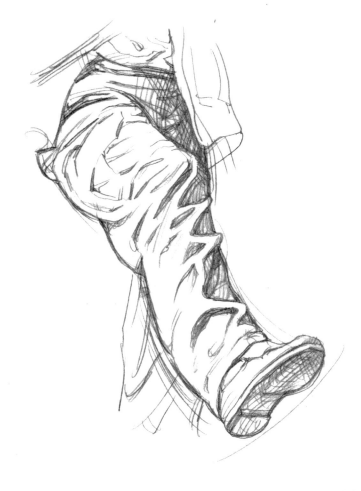

# NUDE AND CLOTHED

In this section (up to page 52) I have collected several studies, which show a procedure suited to capturing the relationship between anatomical structure and the effects produced by a fabric that covers it, and evaluating how far it is possible, in the drawing, to simplify the complex mass of folds in a garment. Naturally this is only an observation exercise in real life, something the artist does by looking at a posed model (first nude and then clothed) or at themselves in the mirror. It is a useful exercise in the early phases when learning to draw clothed figures. Traditional teaching methods suggest that nude figures should be drawn first and the draped fabric, clothing or the costume then superimposed (in a manner of speaking) on them. This method was very popular with sculptors when they made true-to-life dressed figures or when they had a model from

which they could derive the carved work. In other words, it was a way to get to know the inside so as to understand the outside. More recent teaching methods, however, consider such structural and analytical examinations to be of secondary importance and privilege careful and intelligent observation of external forms of figures and their clothing, which are considered as a complex of relationships between volumes and chiaroscuro effects. It would however be a good idea for the artist to try both methods, starting with the analytical one and then perhaps integrating with the other, going back and forth, but then evaluating its effectiveness in harmony with their own personal style or degree of realism or expressiveness that she/he intends to obtain.

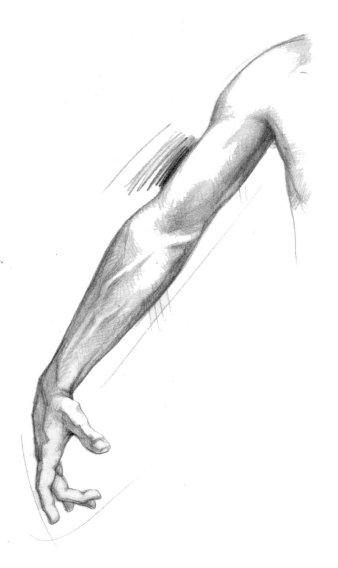

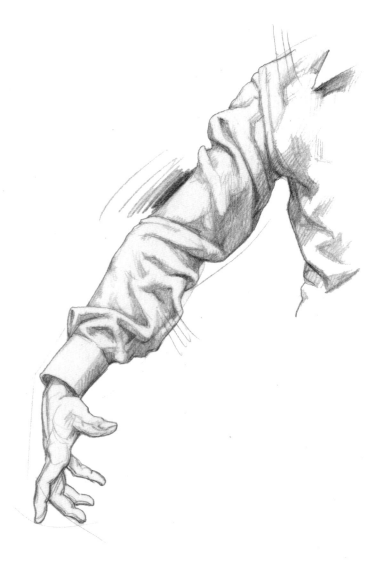

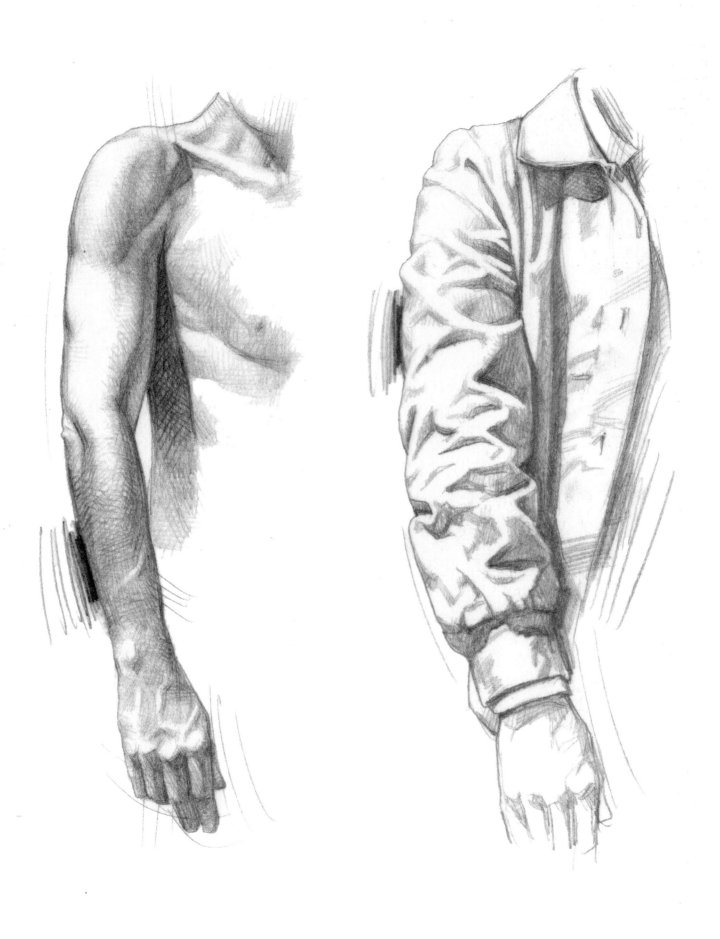

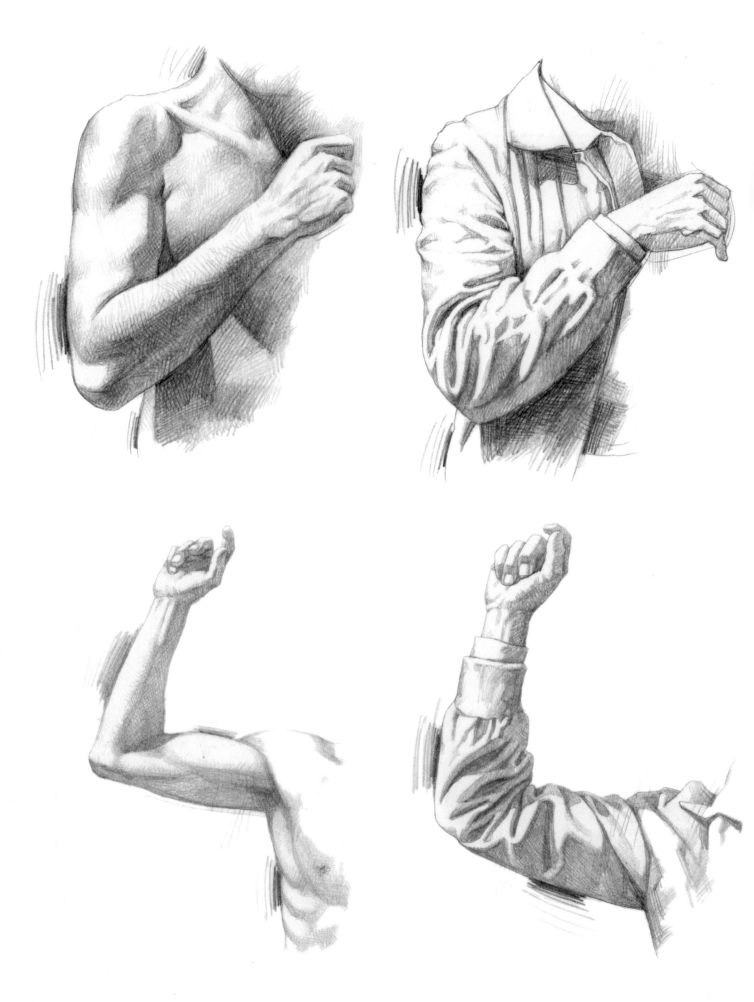

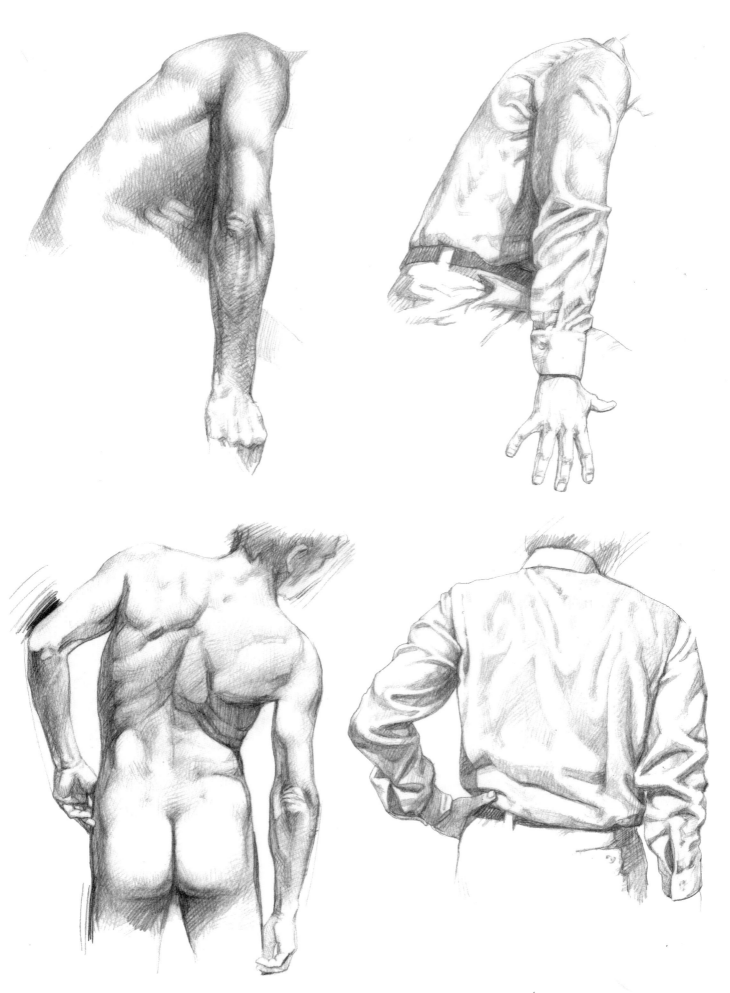

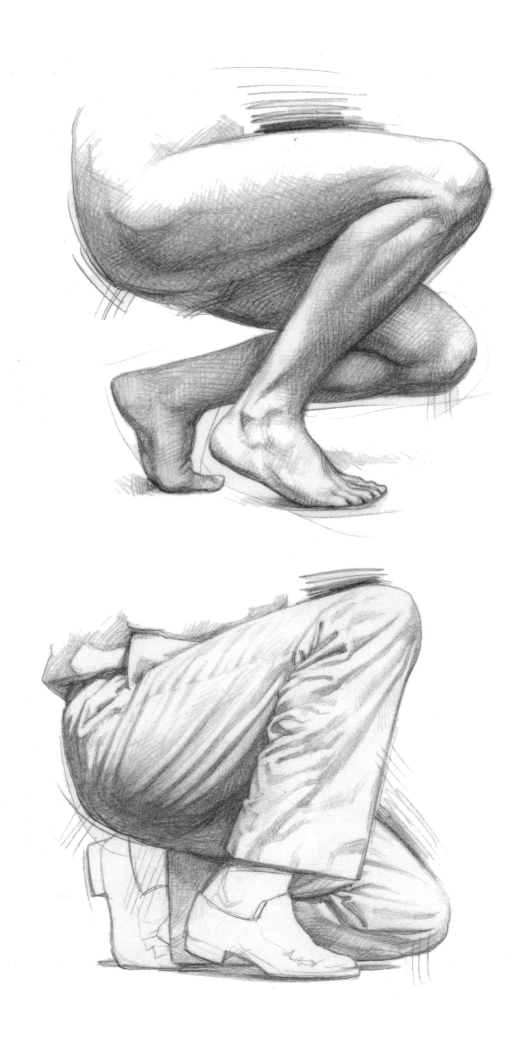

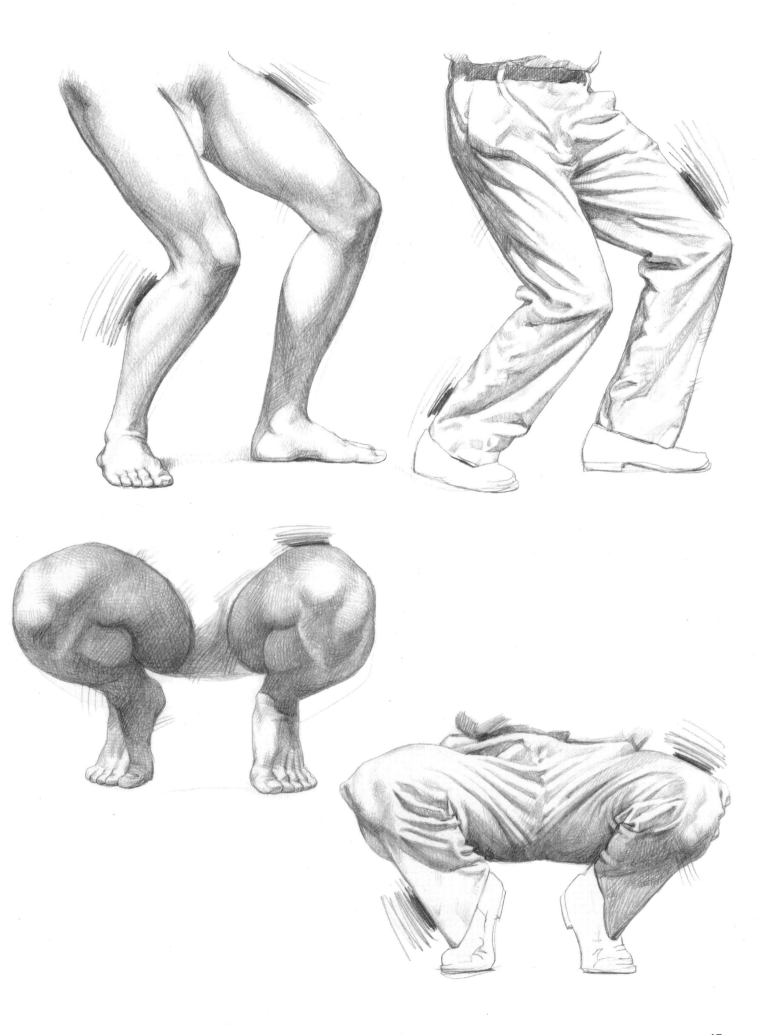

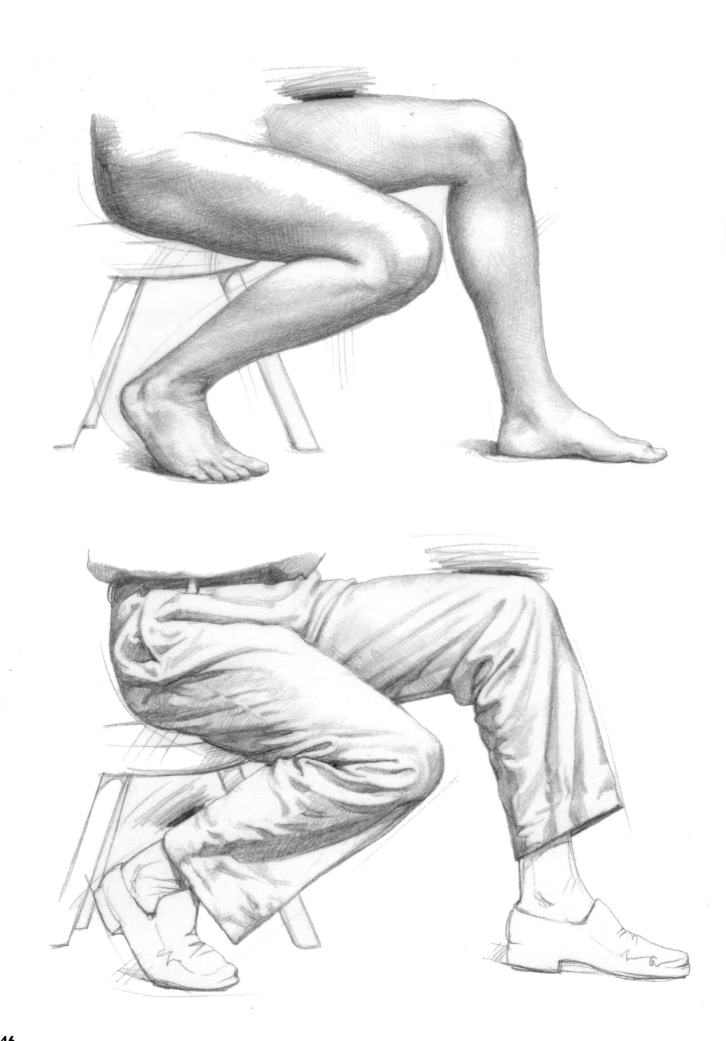

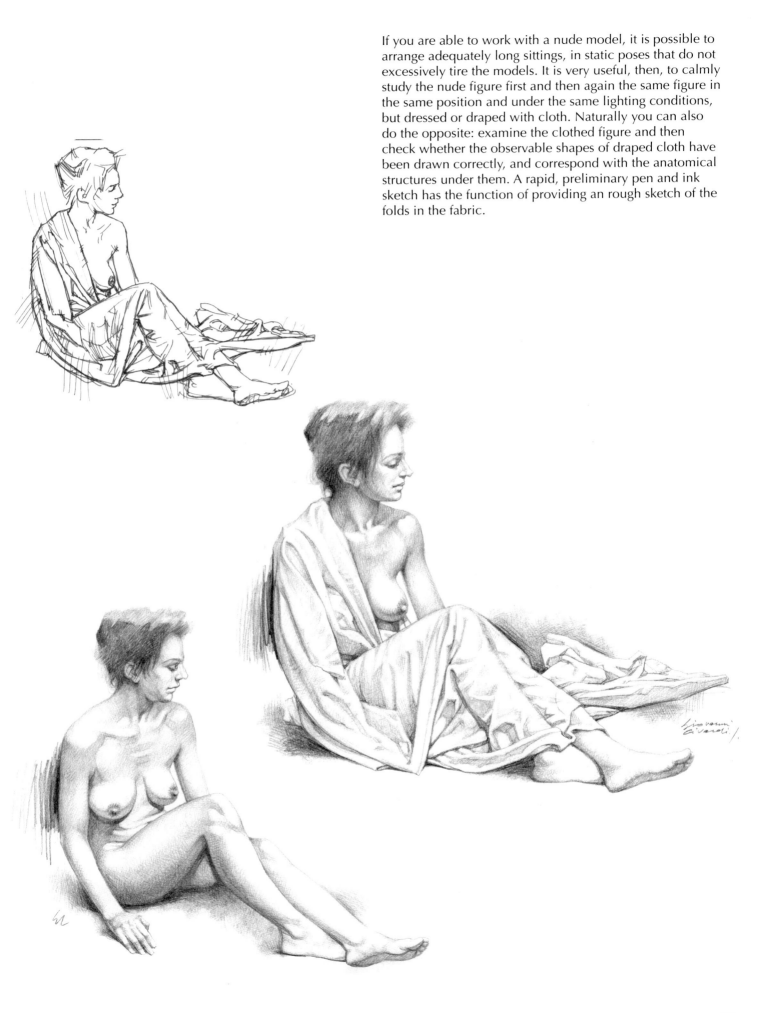

If you are able to work with a nude model, it is possible to arrange adequately long sittings, in static poses that do not excessively tire the models. It is very useful, then, to calmly study the nude figure first and then again the same figure in the same position and under the same lighting conditions, but dressed or draped with cloth. Naturally you can also do the opposite: examine the clothed figure and then check whether the observable shapes of draped cloth have been drawn correctly, and correspond with the anatomical structures under them. A rapid, preliminary pen and ink sketch has the function of providing an rough sketch of the folds in the fabric.

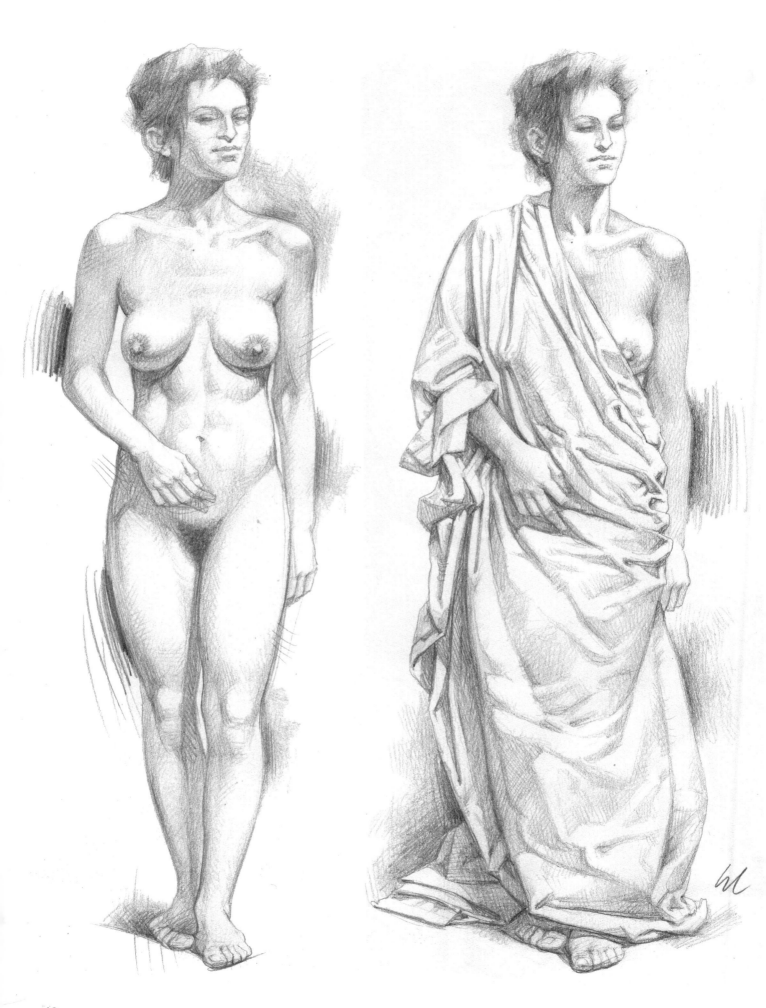

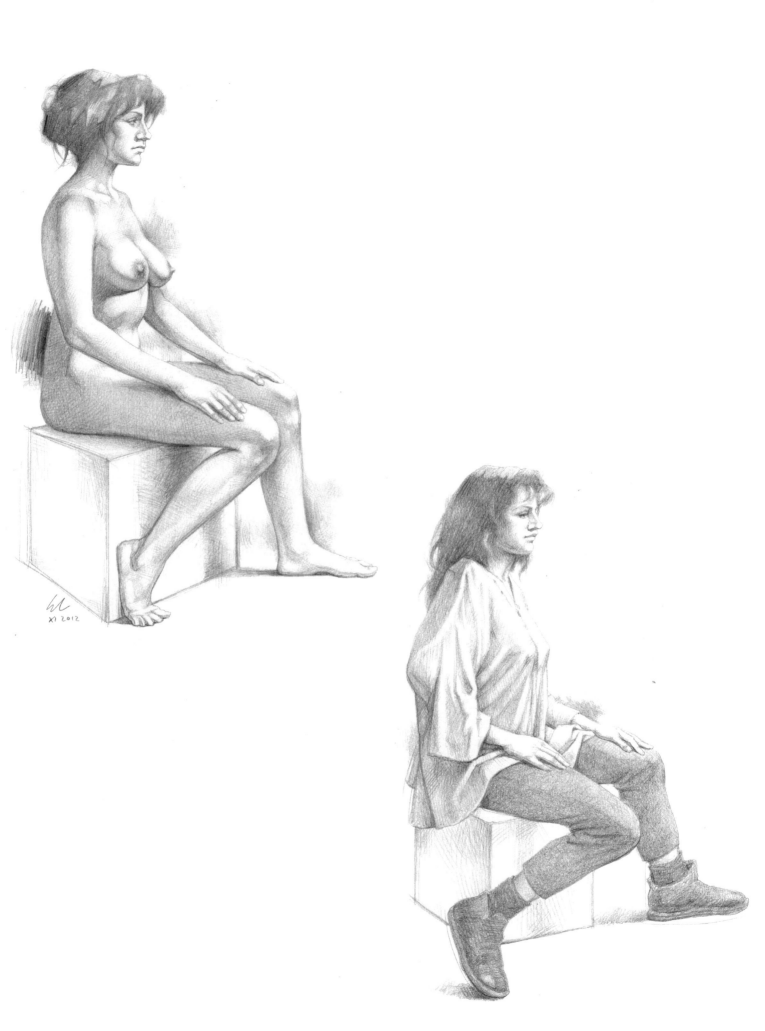

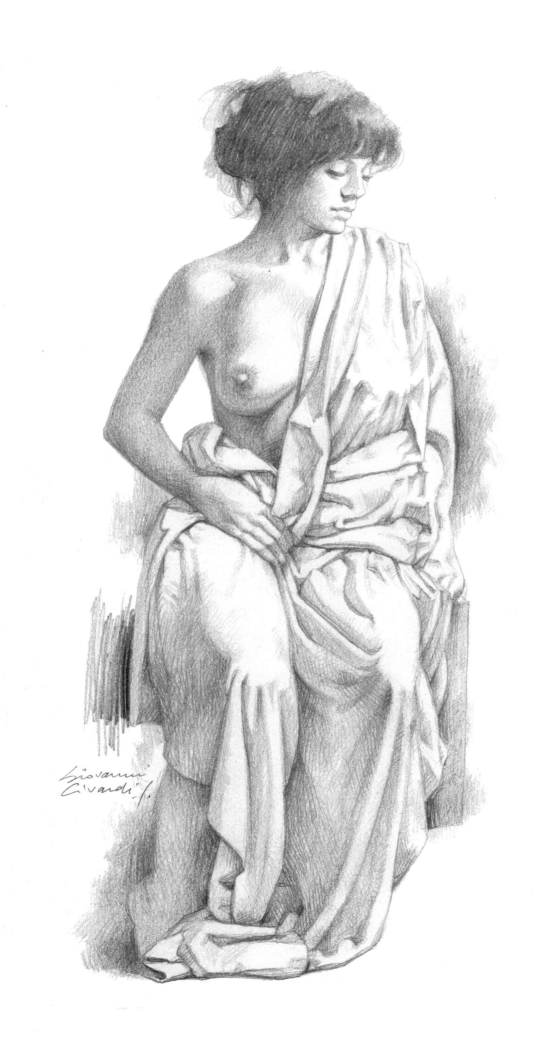

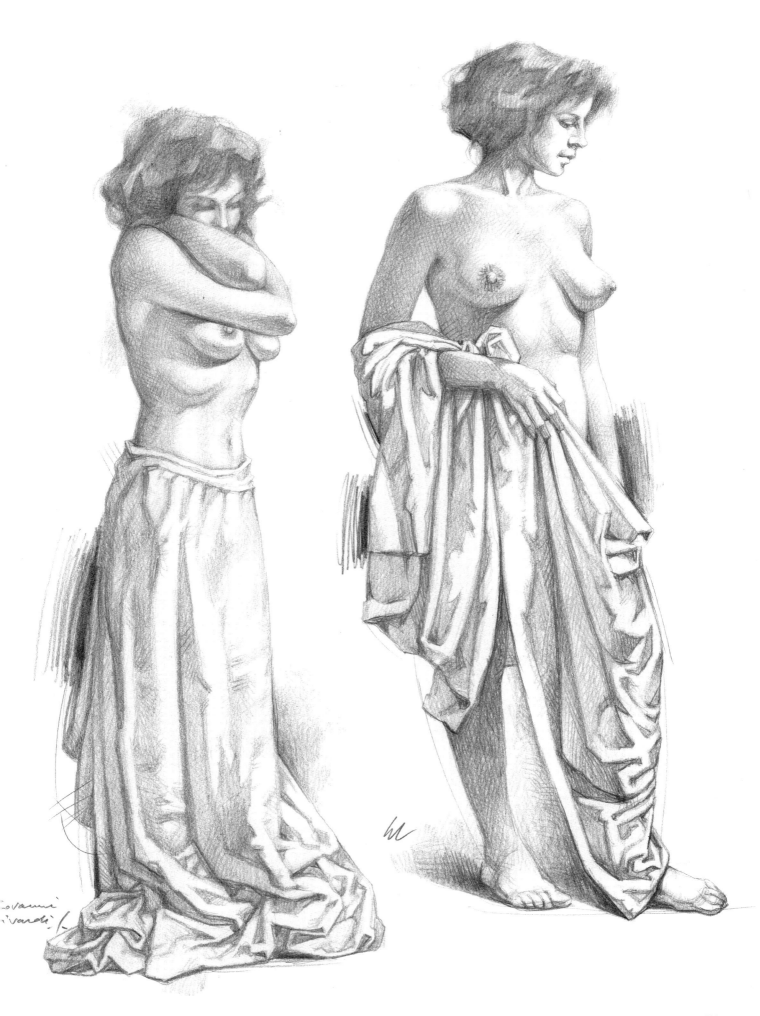

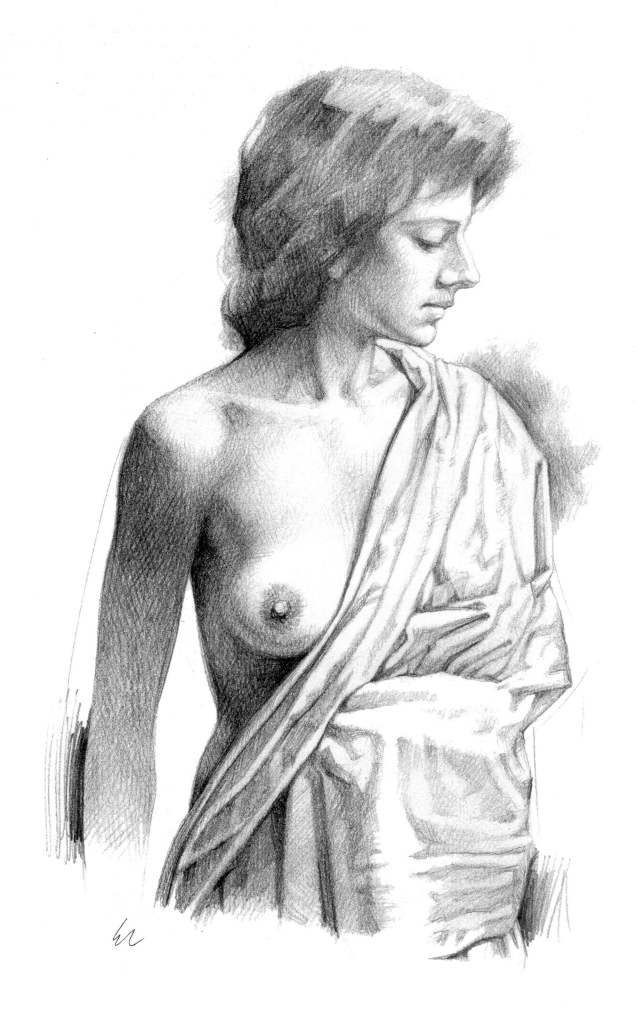

On this and the next few pages (up to page 61), I would like to share a few of my drawings made of sculptures and live models wearing ancient costumes or ceremonial clothing. Both types of subjects are easy to find. Museums contain sculptures from different eras and of different styles that are suitable for accurate study (and without time limits or fear that the model will move …) of drapery and body shapes. Many cities host theatrical shows or historical processions with characters wearing different styles of costumes inspired by the clothing fashions of bygone centuries. For a few years now, in large cities and tourist resorts, it has become quite common to see living sculpture performers (like the one I have drawn here). These are people who put on a show and earn money by standing perfectly immobile for long periods of time, dressed or draped in creative ways in costumes with painted hands and faces.

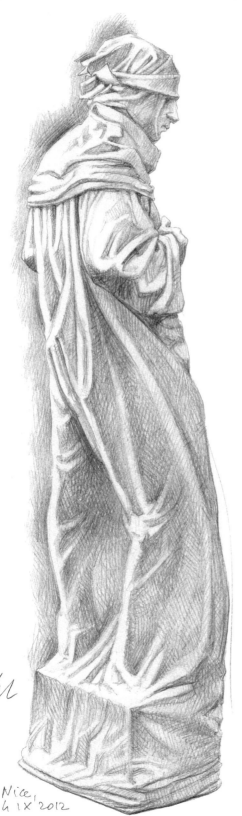

Nice,
4 IX 2012

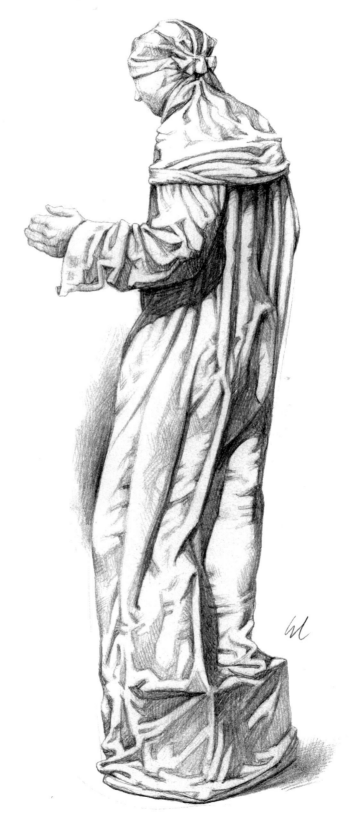

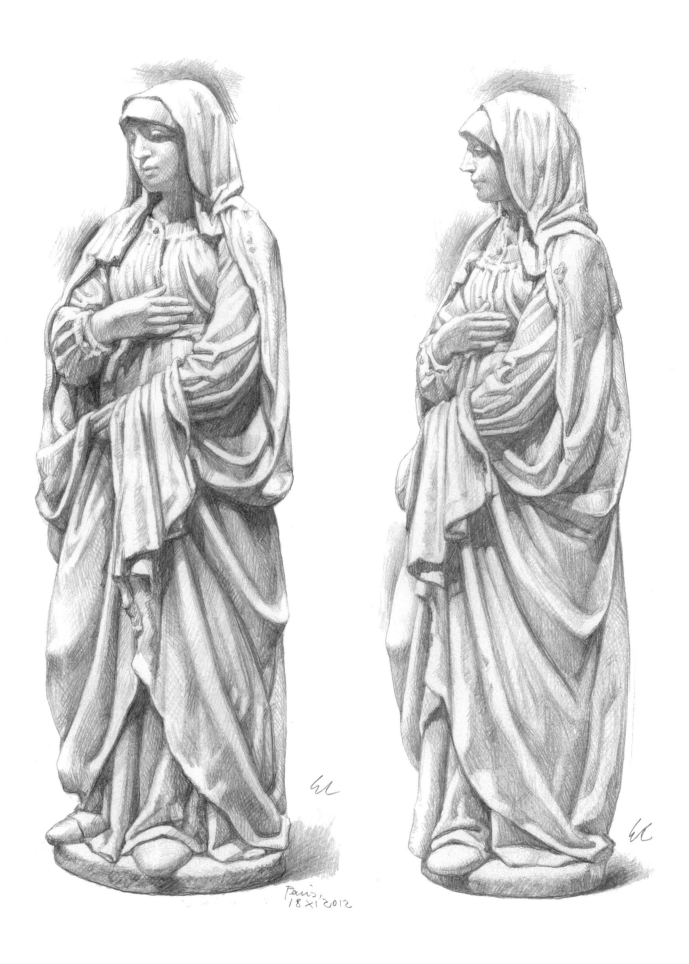

Paris
18 XI 2012

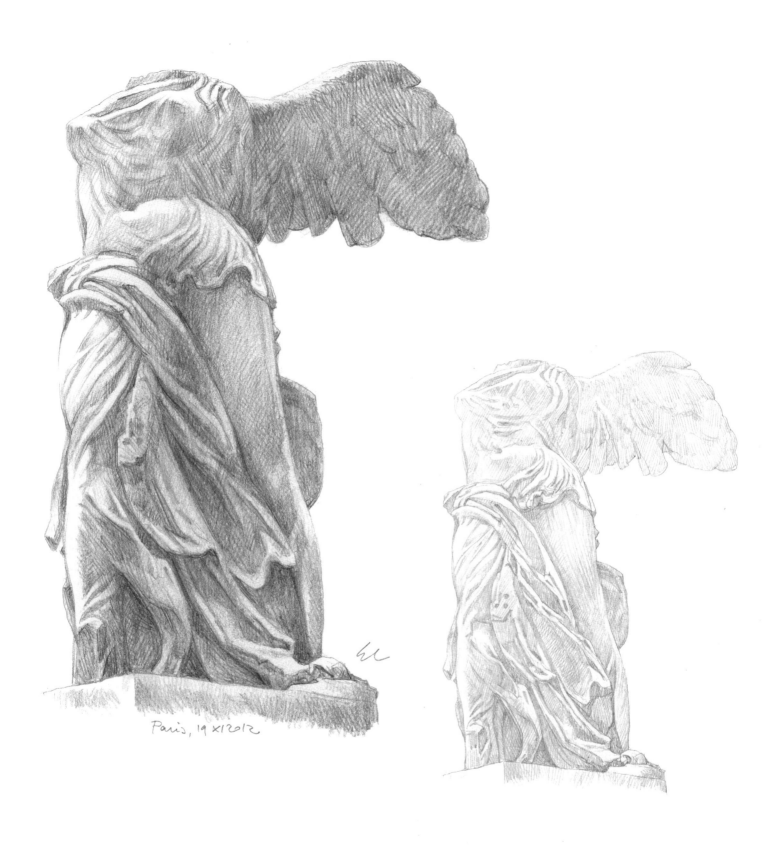

Paris, 19 X12012

Real life drawings can be done in successive stages, when you have time and the desire, the first (and most important) stage being to outline the overall form of the model and the main folds in the clothing draped on it.

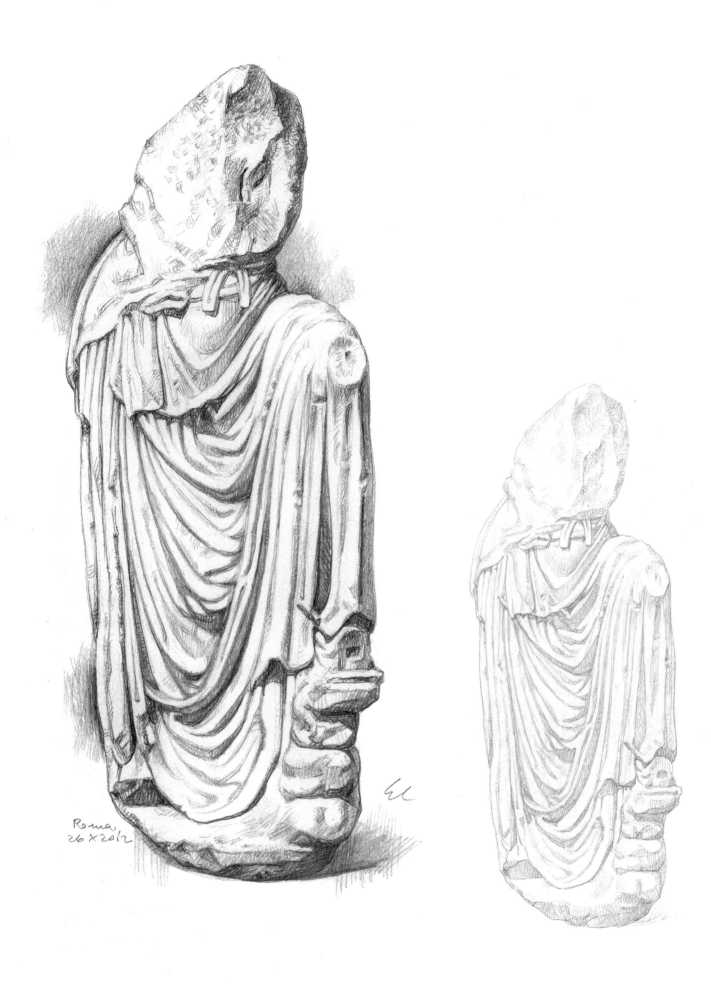

Roma
26 X 2012

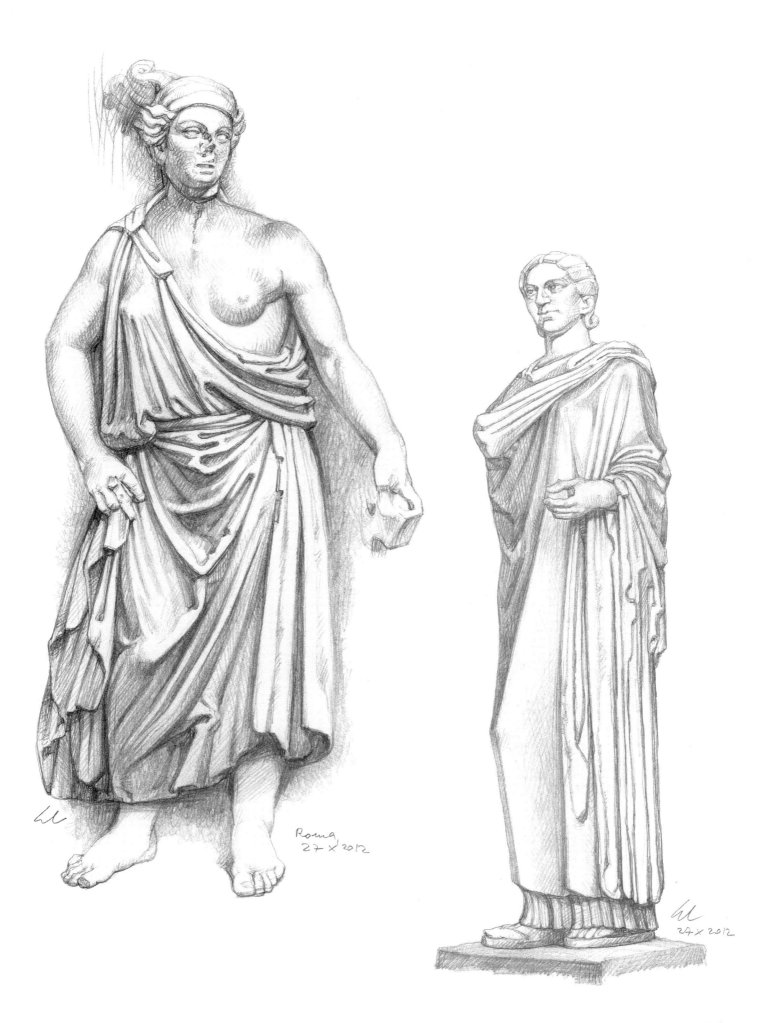

Roma
27 X 2012

24 X 2012

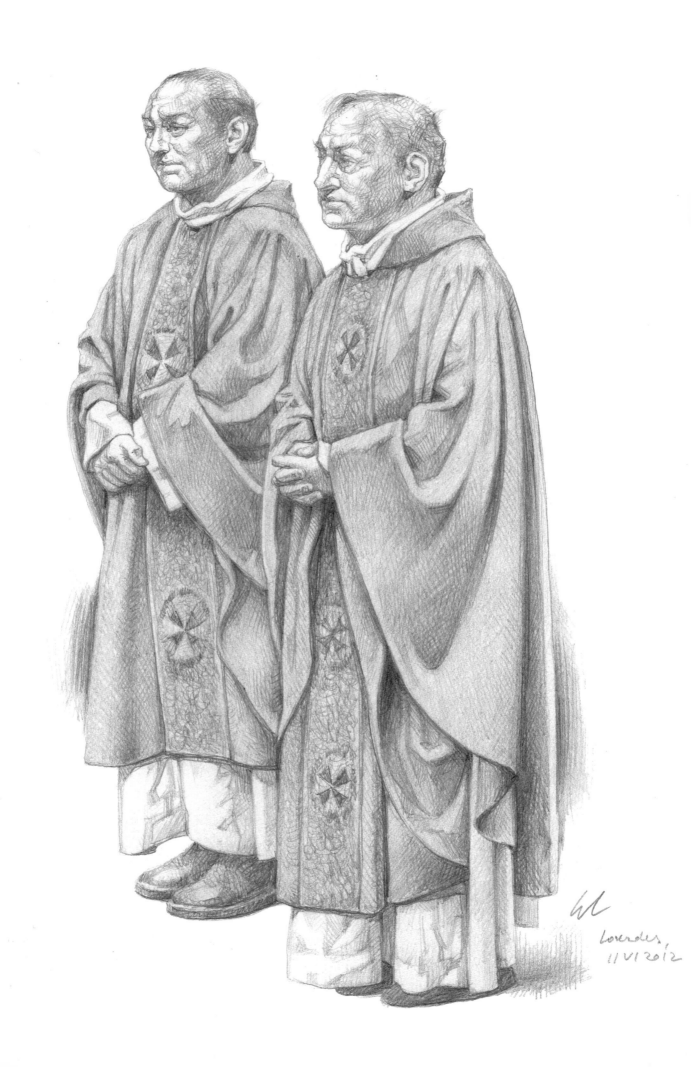

Lourdes,
11 VI 2012

58

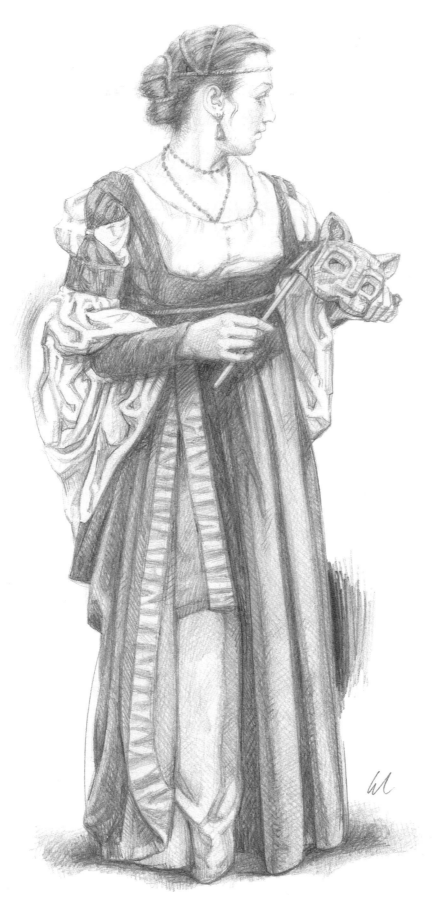

Ancient costumes, especially those from the Renaissance period, and ceremonial clothing are often very elaborate, with large quantities of fabric, variously embroidered and embellished with ornaments and jewels. They do not need to be drawn with punctilious attention to details, as you might do instead for a sketch of a theatrical costume, a fashion design or a stage setting.

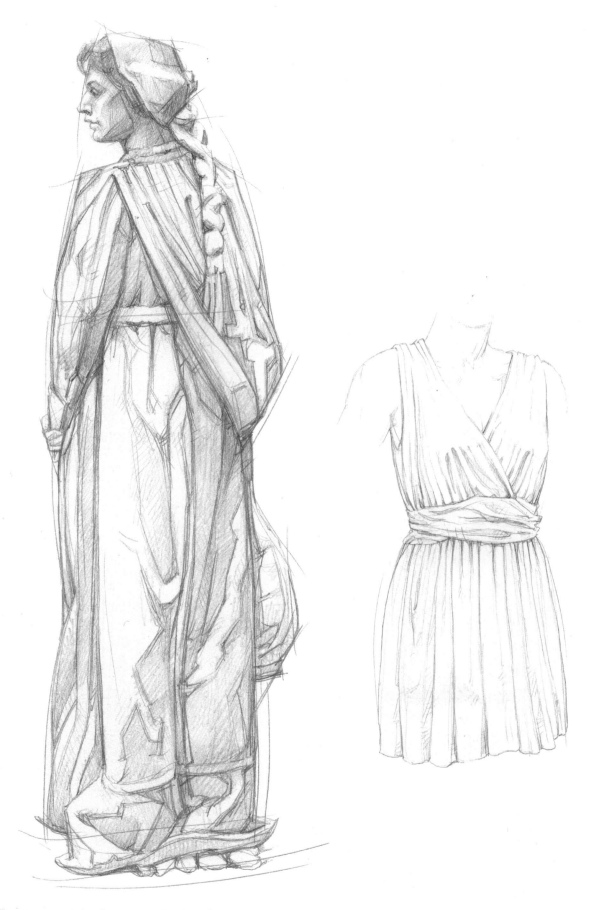

Clothing shops sometimes display various types of garments on mannequins, which are immobile and can be drawn without any hurry. This summer dress, for instance, reminds us of a type of female dress used in ancient Greece, as testified by many sculptures.

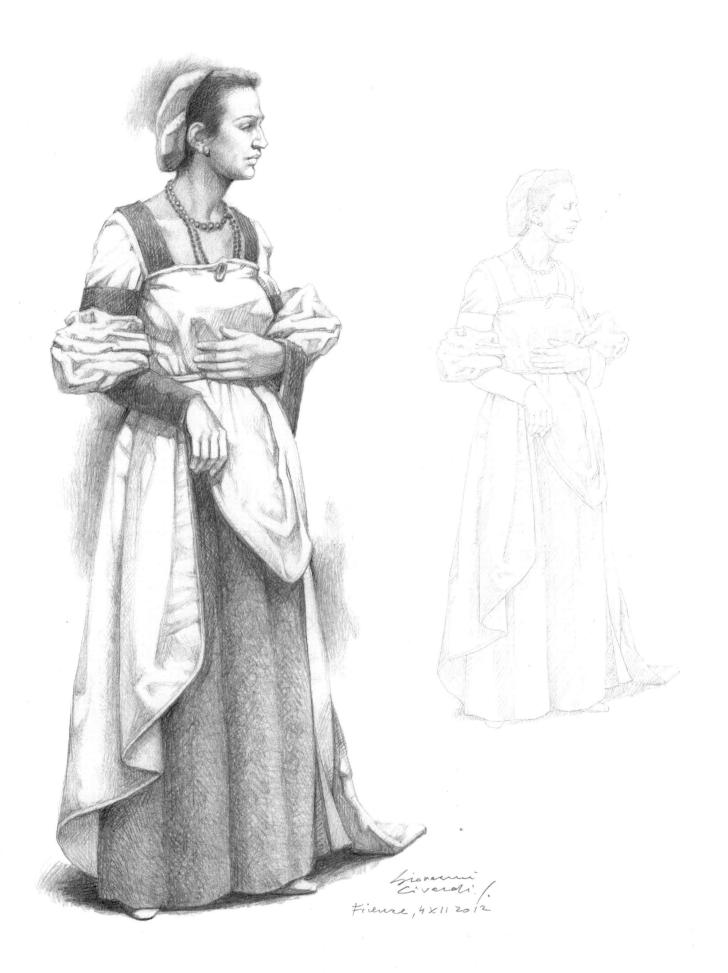

Giovanni
Civardi
Firenze, 4 XII 2012

# PAGES FROM A SKETCHBOOK

In some of my previous books published in this series, I suggested that it might be useful, even today, to create an 'artist's sketchbook' and, to make it a habitual exercise. The sketchbook is a sort of visual diary in which you can record (in the form of simple notes or more elaborate sketches) the images, situations, designs, and studies that the artist happens to view (or seek) in their day-to-day life and which perhaps they will further develop later on. In this book, too, therefore, I have collected a few pages drawn during visits to art museums and monuments …

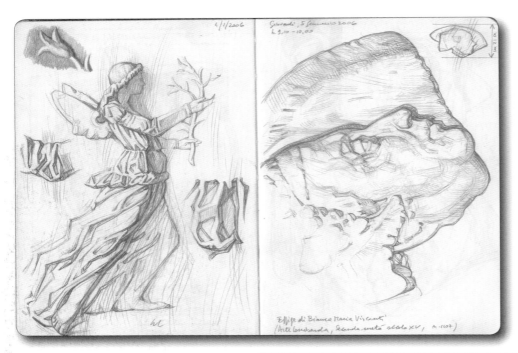

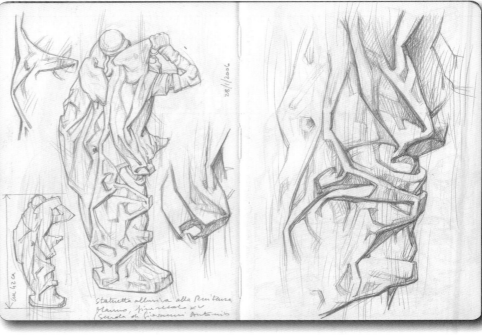

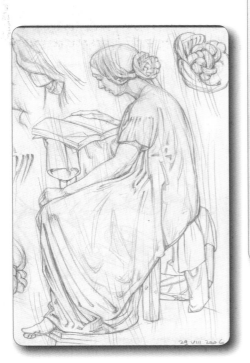

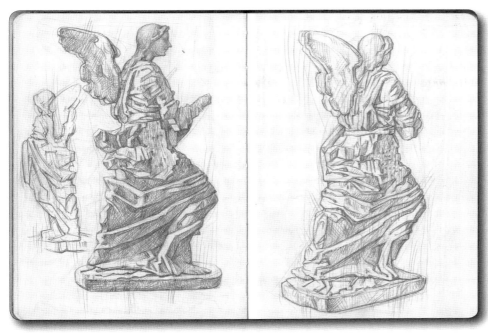

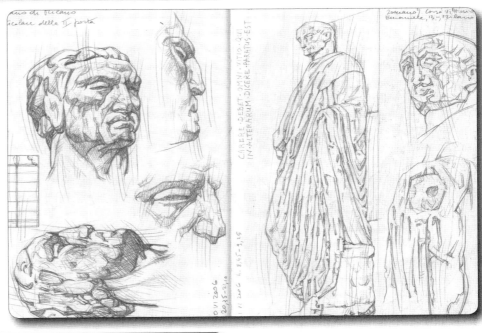

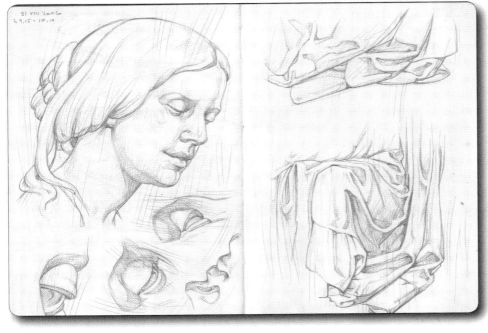

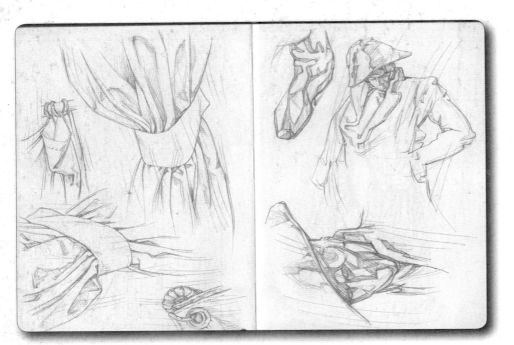

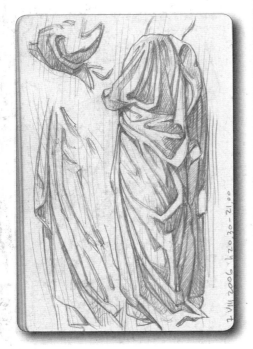

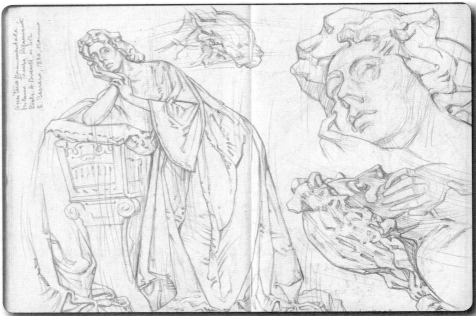

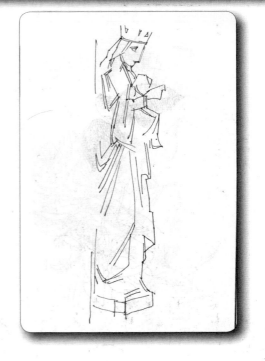